THE ESSENTIAL™

Henri Matisse

BY INGRID SCHAFFNER

THE WONDERLAND
PRESS

Harry N. Abrams, Inc., Publishers

THE WONDERLAND PRESS

The Essential™ is a trademark
of The Wonderland Press, New York
The Essential™ series has been created by The Wonderland Press

Series Producer: John Campbell
Series Editor: Julia Moore
Project Manager: Adrienne Moucheraud
Series Design: The Wonderland Press

Library of Congress Catalog Card Number: 98-074611
ISBN 0-8362-1937-6 (Andrews McMeel)
ISBN 0-8109-5816-3 (Harry N. Abrams, Inc.)

Distributed by Andrews McMeel Publishing
Kansas City, Missouri 64111-7701

Unless caption notes otherwise, works are oil on canvas

Printed in Hong Kong

Harry N. Abrams, Inc.
100 Fifth Avenue
New York, NY 10011
www.abramsbooks.com

Contents

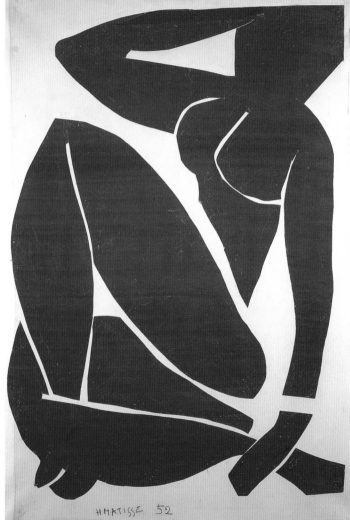

The Thing About Henri

A collector once asked Henri Matisse how long it took him to render some extravagantly expensive work that consisted of a few breezy lines. Matisse responded, "A lifetime."

This little anecdote says a lot about Matisse:

- His art is deceptively **simple-looking**.

- He **struggled** throughout his career to achieve that look.

- He is an established **master of modern art,** whose work inspires legend, scholarship, and high prices in marked disproportion to the visible amount of labor that goes into it.

- He was given to **imperious** (and highly quotable) remarks.

> **FYI:** The 1997 price for Matisse's 1915 painting *The Yellow Curtain* was $20,000,000.00.

Henri Matisse (1869–1954) is generally considered, along with Pablo Picasso (1881–1973), **the most important innovator of 20th-century art.** He is famous for paintings steeped in color and reduced in

ABOVE
The Yellow Curtain. c. 1915
57 ½ x 38 ⅛"
(146 x 97 cm)

Collection Stephen Hahn,
New York, N.Y., U.S.A.
Art Resource, NY

OPPOSITE
Blue Nude III
1952. Gouache on
paper, cut and
pasted. 44 x 29"
(112 x 73.5 cm)

means—paintings that express the tremendous pleasure to be had in a purely visual experience. His pictures are of the most conventional studio subjects known to art: pretty women posed in lovely interiors, flowers, portraits, views outside the window. And yet Matisse used these old chestnuts to convey **a new vision:** He promoted modern approaches to art based almost entirely on color and design.

For Matisse, a generic image of a woman staring at a goldfish produces a motif of reverie and introspection that is both enduring and modern. Her mind is in a state of abstraction and Matisse uses every component of his art—color, drawing, space, design—to represent that state so completely that it's irresistible. To view a work by Matisse is to surrender one's self to the physical and intellectual act of looking, which every aspect of his work celebrates. And *celebrate* it does, in a triumph of:

- color in line

- tension in repose

- economy in luxury

- continuity in invention

- limitless nature (our finny friend) inside of a room.

These are just some of the oppositions Matisse worked hard

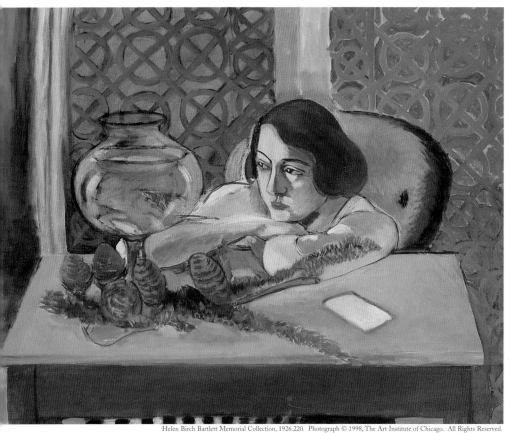

throughout his entire career to **reconcile through art.** That's the thing about Henri: His art is *essentially* about art, just as his life was about *making* art. He approached his work with:

OPPOSITE
Basket of Oranges
1912. 37 x 32 ⅝"
(94 x 83 cm)

- a keen intellect

- a bourgeois sense of propriety

- a highly developed sense of artistic legacy.

To appreciate his work is to immerse yourself in the art and issues that consumed him.

Sound Byte:
"Oh, do tell the American people that I am a normal man, that I am a devoted husband and father, that I have three fine children, that I go to the theater, ride horseback, have a comfortable home, a fine garden that I love, flowers, etc., just like any man."

—MATISSE, explaining to an interviewer why
he was not a bohemian

One Essential Message

His entire career—from its spectacularly prolonged student years to a paradise of hotel-living with a stream of beautiful models dressed in

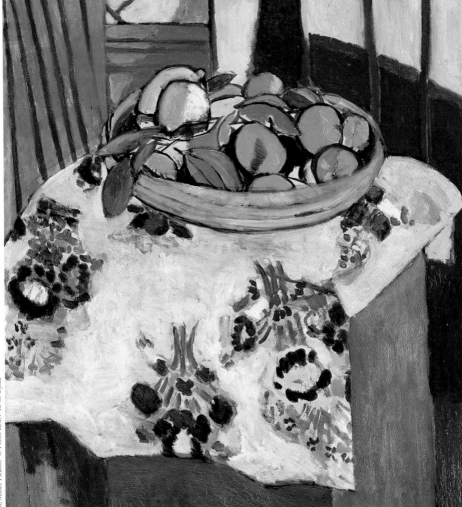

harem pants and plumed hats at his disposal—comes down to **one essential message:** Matisse worked and reworked each line, even at the height of his fame, when his art appeared in its most deliciously easy style—big nudes cut out of blue paper. The surfaces of his paintings are covered with the signs of erasing and starting over. The serenity he captures in art does not reflect his own temperament. (Matisse was a nerve-ball, suffering chronic anxiety.) These contradictions are as fascinating as the beauty of Matisse's work is evident. And once you get the essence of reconciliation—*how Matisse's art can be, say, both simple and complex at once*—you see how profoundly beautiful it really is.

It's no big mystery. This book tells you what you need to know about Matisse's life and times, his art and its relationship to the major phenomenon of Modernism. So the next time some churlish boor quibbles *how* (and for cripe's sake *why*) did it take a so-called master of modern art all that time and effort to make works that could *not* look easier, you (who now have the essential message at hand) can quip with authority: *It ain't as easy as it looks.*

Sound Byte:
"I have always tried to hide my efforts and wished my works to have the light joyousness of springtime, which never lets anyone suspect the labors it has cost me."

—MATISSE

Armchair Radical

In his *most* quoted remark, Matisse said that he wanted to make art that was like an armchair. He dreamed of "an art of balance, of purity and serenity devoid of troubling or depressing subject matter, an art that might be for every mental worker...like an appeasing influence, like a mental soother, something like a good armchair in which to rest from physical fatigue." To today's ear this sounds rather quaint: *Matisse, the nester.* But in 1908, the implications were radical, in part because it promoted the notion of **art as décor,** which, to cultural "purists," implied something less than the lofty aspirations of traditional painting and sculpture. The fine arts were supposed to deal in big things—religion, history, moral and philosophical allegory. The decorative arts were eye candy—patterns in the carpet, knickknacks on tables, gorgeous hats. And yet Matisse was completely sincere when he likened his art to the latter. **He believed that beauty for pleasure's sake was culturally important.** At the time, such an ambition was as astonishing and quintessentially modern as the newly built Eiffel Tower.

Thoroughly Modern Matisse

Art-historically speaking, Matisse is considered a **Modernist.** This is a sweeping term used across the 20th century to declare a break from

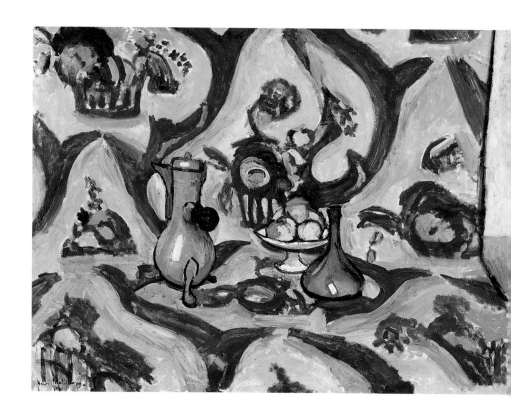

the previous century and from historicism in general. "History is bunk," declared modern industrialist Henry Ford. Instead, Modernists were determined to represent the present, the here and now—socially, politically, culturally, psychologically. James Joyce was a Modernist in literature; Igor Stravinsky was one in music.

OPPOSITE
Still Life with Blue Tablecloth
1909
34 ⅝ x 46 ½"
(88 x 118 cm)

In art, there are many movements within Modernism (Cubism and Futurism are two). Matisse made his mark through **Fauvism** (we'll get to that in a moment), then went on to work independently and outside of Paris **as a high priest of Modernism.** And yet, as we'll see, Matisse stands in curious relation to its ideals.

Sound Byte:
"Since his death, Matisse's reputation has steadily increased as one of a select group of artists who radically defined the language of painting in the 20th century."

—NICHOLAS WATKINS, art historian

Some Modernist Ideals:

- **EMPHASIS ON FORMAL INNOVATIONS:** color, structure, words, even musical notes are seen as objects of meaning in their own right. (A Modernist mantra, as penned by author/patroness **Gertrude Stein** [1874–1946]: *A rose is a rose is a rose.)*

13

OPPOSITE
*Odalisque with
Red Culottes*
1921
26 $^3/_8$ x 33 $^1/_8$"
(67 x84 cm)

- **KEEP IT SIMPLE:** Modernists avoided excessive ornament and detail in favor of streamlined and self-contained forms of expression. (A Modernist quip coined by artist **Frank Stella** [b. 1936]: *What you see is what you see.*)

- **COMMITMENT TO PROGRESS:** From Ford Motor Company assembly lines to Matisse's armchair art painted for workers, Modernism is propelled by ideals of collective good. **(Franklin Delano Roosevelt's** [1882–1945] Modernist political slogan: *A chicken in every pot.)*

Matisse embraced these ideals and claimed a few of his own:

- He was **extremely aware of the past** and worked to preserve a sense of continuity with it.

- He was **passionate about decoration.**

- **His art** *refuses* **the outside world** by depicting private oases of pleasure, cut off from speed, industry, the masses, and other modern-day conditions.

Then why is Matisse's art "modern"? Generationally, Matisse was a man of the late-19th-century *Belle Epoque* period of feminine beauties, ornate interiors, and grand style. Thus, one might say that *even on a personal level,* he worked to **reconcile** his 19th-century past with his 20th-century cultural moment.

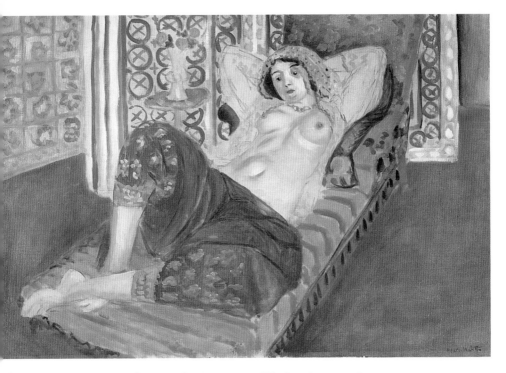

In terms of his specific contribution to art, Matisse is revered as a **colorist** and was hugely influential as such. For example, the painter **Mark Rothko** (1903–1970) claimed he was directly inspired by Matisse when he conceived of his **Abstract Expressionist** canvases of luminous fields of pure color.

INTERMISSION:
THE WONDERFUL WORLD OF COLOR

If you've ever painted a room, you know how difficult it is to match a paint chip to a desired color; you also know much color changes from chip to room-size and how many shades of white there are to choose from. Now imagine that there are theories for all these problems: Welcome to the world of colorists.

The uses and representation of color form a major subplot in the history of Western painting. It's an insider's story, seething with intrigues of **local color** (the lemon *is* yellow) vs. **reflected color** (but the blue bowl sitting next to it makes it *look* green); **symbolic color** (his hair *feels* magenta) vs. **simultaneous contrast** (that red looks like hot pink next to that orange, but it looks deep purple next to that green); **brightness** (more white) vs. **hue** (more pigment). It can also sound mysteriously like alchemy *(primary pigments, subtractive mixtures, color wheels)* with **black,** which represents the absence of color, which does not actually exist in nature, and which, paradoxically, is the sum of all colors. On the viewing side, it's enough to be aware that for an artist as involved as Matisse was with these minutiae, every color emerges as the result of sensitive mixing and harmonizing to create a precise impression. Matisse's color perceptions were so sophisticated that he could alter the appearance of things through manipulation of color.

No Child Prodigy

And so the story begins: Henri-Émile-Benoît Matisse is born on **December 31, 1869,** at Le Cateau-Cambrésis on Flanders Field, in the northern French province of Picardy. His home turf in nearby Bohain will become one of the first points of **reconciliation** for Matisse's future art: The *gray and flax-colored landscape* of Picardy is the polar opposite to the *color-saturated* Mediterranean with which he is identified. There is little in Matisse's middle-class family background that points to art. His father, a prosperous grain merchant, instills in his son a love of music (Matisse learned the violin) while marshaling him toward a career in law. Matisse owes his latent artistic tendencies to his mother, **Anna Matisse,** who dotes on her sickly oldest son (Matisse grows up with one brother; another dies in infancy). She is known for her decorative flair, especially in matters of color. Before marrying, she worked as a milliner. (We'll see lots of hats in Matisse's work—and Dad's violin will figure throughout the artist's life.) As a child, however, Matisse is not known to be inclined to paint or draw, or in any way to be a prodigy.

Matisse at the time of his marriage to Amélie Parayre 1898

> **FYI:** A tiny clue lurks in the cellars of local farmers, where many spent the winter months industriously *weaving.* Decorative textiles will appear as important structuring devices in Matisse's future art.

Art Therapy

During the years 1887 to 1890, Matisse attends law school in Paris, gets his degree, returns home to work as a clerk, and endures an attack of appendicitis. While recuperating at his parents' home in Bohain, Matisse starts to paint using a box of colors borrowed from his mother. His first work is a dull-toned still life of books dated June 1890. Competent but not remarkable.

> **FYI:** Having come to art through illness, Matisse will maintain his faith in the healing power of art. When friends are sick, he prescribes his own paintings to be hung in their bedrooms as therapy.

Proceeds with Caution

Matisse returns to work at the law firm, paints in his spare time, and in 1891, much to Dad's dismay, announces he wants to go to art school. Now, here's the thing: Matisse, age 22, is starting from scratch when his generational peers are already leaving the Academy and becoming **the next hot thing.** Matisse, as staid and bourgeois as his background, seems oddly lacking in artistic temperament. And yet, in yanking himself off the track of a secure legal career to pursue something as elusive as artistic fame, Matisse clearly has a vision. At the

same time, his conservative background makes him work hard and progress with caution. Compared to those of his creative peers who, in true avant-garde fashion, eagerly move ahead, Matisse's progress is that of a cautious older man. He advances, stops to get his balance, maybe falters a few steps back, retrenches, then takes amazing strides on unforeseeable new grounds.

Sound Byte:
"It was with the constant knowledge of my decision...that I took fright, realizing that I could not turn back. So I charged, headlong, into my work, following the principle drummed into me all through my youth, which was, 'Don't waste time!'"

—MATISSE

The Student Decade (1891–1900)

Matisse's art school experience is emblematically Modern: He learns his most meaningful lessons through assimilating and rejecting the established values represented by the Academy. Even though, ultimately, he will make his own way, he sets out to attend the state-funded École des Beaux-Arts in Paris. To prepare for the entrance competition, he enrolls in October 1891 at the private Académie Julien under the arch-conservative **William Bouguereau** (1825–1905), a master of

lick-and-tickle paintings of luscious nymphs. Matisse is not impressed, particularly when he sees the Master making exact copies *of copies* of his own most popular works.

> **FYI:** In 1915, Pierre Bonnard radically modernized his painting style to focus on issues of abstraction that express his own sensual reactions to life. Today, Bonnard is considered a Colorist on a par with Matisse.

Strike One...

In February 1892, Matisse fails the entrance exam to the École. Crushed, he joins the flock of student hopefuls who gather to draw from casts of classical sculpture in the courtyard of the École, where instructors must pass by. Matisse's work catches the attention of the Symbolist painter **Gustave Moreau** (1826–1898), who invites Matisse to unofficially attend his classes. Henri maintains his academic status (and his allowance) by taking classes in geometry and perspective at the École des Arts Décoratifs, which specializes in textile and tapestry design. There he meets **Albert Marquet** (1875–1947), who will become a fellow Fauve and lifelong friend.

BACKTRACK
THE INTIMISTS

The next hot thing, circa 1880, as represented by **Édouard Vuillard** (1868–1940) and **Pierre Bonnard** (1867–1947) is **Intimism:** an imagery of everyday life, of figures in domestic interiors. The painting is flat, crowded with the decorative patterning of carpets, wallpaper, fabric; the space is compressed; colors are suppressed; details are reduced. (It's a Victorian-period meltdown.) Except for the studied claustrophobia that pervades Intimist painting, it's interesting to note how much in common Matisse's Modern art (flat, reductive, decorative, intimate, and interior) ultimately shares with his true generational peers.

BACKTRACK
ÉCOLES & SALONS

The most powerful academy in France, the École des Beaux-Arts, was part of a centuries-old system. Students took standardized classes under the leading artists of the day and participated in annual public exhibitions, or Salons, for prizes that translated into government commissions, sales, and, if you were lucky, a prestigious teaching job at the Academy. It was a circular system that protected its own by resisting outside influences from independent-minded interlopers. By the time Matisse entered into the Academy, the system was showing signs of stress. A **Salon des Refusés** was instituted in 1881 to accommodate all the artists who were refused permission to exhibit in the official Salon, till then the only public exhibition of contemporary art in France. Soon other renegade Salons sprang up: the non-juried **Salon des Indépendents** held in the Spring, and the juried **Salon d'Automne** (founded in 1903), held in the Fall, both of which would be important venues for Matisse.

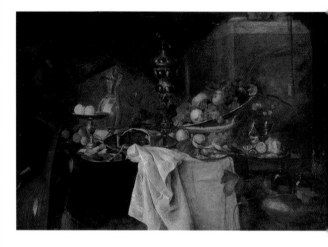

Learning by Rote

Moreau encourages students to copy masterpieces at the Louvre. During his student decade, Matisse copies thirty works by various artists—two of whom are of particular interest for establishing *oppositions that Matisse will struggle to reconcile throughout his art*, while displaying predilections for both:

- The Dutch still-life painter **Jan Davidsz. de Heem** (1606–1683). Matisse's very first copy is of de Heem's *La Desserte* (he'll copy it again during his Cubist phase). De Heem's art is an imagery of

opulence: luxurious with dishes, heaped with food, all rendered in succulent detail, **painted to please a rich bourgeois palette.** It portrays the theme of *vanitas:* the food will rot, the silver will tarnish, everything on earth is fleeting, curry your soul for heaven *now!*

- The French still-life painter **Jean-Baptiste Chardin** (1699–1779). Matisse copies five of his works. Chardin's still lifes are spartan, reduced both in their subjects (a book, a glass, a pipe) and in their depiction. Details are suppressed in favor of overall pictorial structure. Chardin wishes to **appeal to the contemplative eye.** By means of their **absorbing intimacy,** these works compel the viewer to appreciate the moment.

Financial and Domestic Notes

Throughout his student years, Matisse anxiously receives a small allowance from his father, who regularly threatens to rescind his support. He finds a studio in a building at 19, quai Saint-Michel, where he will work until 1908, and again starting in 1913. The student Matisse isn't alone, though: He's living with a woman named **Caroline Joblaud,** who gives birth to their daughter, **Marguerite Émilienne,** on September 3, 1894.

OPPOSITE
La Desserte (after Jan Davidsz. de Heem). 1893
28 ³/₄ x 39 ³/₈"
(73 x 100 cm)

Matisse Makes it to First Base

OPPOSITE
Woman Reading
1895
24 ¹/₄ x 18 ⁷/₈"
(61.5 x 48 cm)

After failing the entrance exam a second time in 1894, Matisse finally passes and is accepted to the École des Beaux-Arts in 1895. By 1896, things are looking up. In the spring, he sells two works in a Salon exhibition, including *Woman Reading*, which is bought by the state and winds up in President Félix Faure's summer chateau. Stylistically, it's lackluster Intimism, but thematically, it introduces a major theme in Matisse's art: **a woman, absorbed in abstraction, mysteriously caught up in her own silent world.**

Based on this relatively conservative performance, he is nominated an associate member of the Société Nationale des Beaux-Arts by its president, **Puvis de Chavannes** (1824–1898). Contrast Puvis (pronounced "Pooh-Vee") and Moreau as mentors and you have another pair of reconciliations for Matisse's art. Made for private consumption, Moreau's jewel-like paintings are exotic and decadent. Puvis created faux-fresco murals in pale colors for public settings to convey progressive social values through elegant images of a Classical golden age—one soon to be summoned by Matisse.

> *FYI:* Paradoxically, in contemporary art and politics, the "golden age" was synonymous with anarchism. Bring down the bourgeosie and bring on utopia—a classless society, beyond industrialization, where everyone lives in communal harmony.

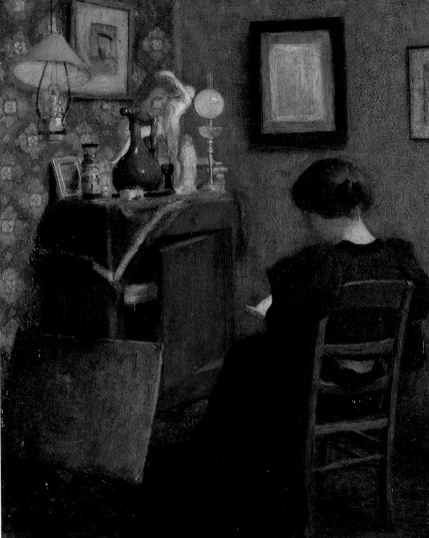

Based in Paris, the key figures are painters Édouard Manet (1832–1883), Claude Monet (1840–1926), Camille Pissarro (1830–1903), and Pierre-Auguste Renoir (1841–1919). The Impressionists attempted to almost scientifically represent their *perceptions* or *impressions* of the transient effects of light and movement on the visual world. Dappled brushwork dissolves into atmospheric compositions and vibrant colors, rendering a *realism of the moment*. They were motivated by naturalism, but they introduced a concept of painting based on extreme artifice that transferred attention from external subjects (nature) to subjective perceptions (the artist's eye). This is what makes Impressionism so essential to the development of Modernism: *It grants possibilities for abstraction.*

STRIKE OUT!

Moreau encourages Matisse to make his **first big painting,** which he begins work on in late 1896. (In the Salon system, *scale* equaled importance, when pictures of all sizes were exhibited practically floor-to-ceiling.) The result is *The Dinner Table,* a picture of a woman preparing a table well laden with fruit, wine, dishes, glasses, and silver (a **de Heem** display of goods). The model is Caroline, who will be out of the picture by the end of the year, when the couple separates. Here she appears absorbed in her arrangement, exuding (a Chardinesque) domestic calm. She is costumed as a Breton serving girl (Matisse will evolve as a consummate costumer of women), in reminiscence of the Northern Coast, where the couple had been spending their summers. When *The Dinner Table* is shown at the 1897 Salon de la Société Nationale, Matisse unwittingly alienates his fellow members, who are offended by brushwork that screams of **Impressionism.** With its creative heyday back in the 1870s, Impressionism was hardly cutting edge in 1897. But it still rankled the Academy, *especially* with the first exhibition of the Caillebotte Bequest, an exhibition Matisse attended in

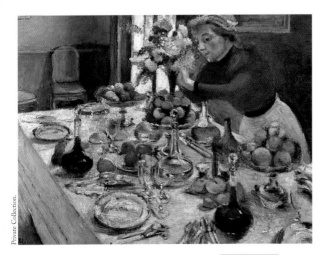

The Dinner Table
1896–97
39 ³/₈ x 51 ¹/₂″
(100 x 131 cm)

the company of his new friend **Camille Pissarro** (1830–1903), a *bona fide* Impressionist (and, for added rankling effect, an outspoken Socialist). At first, Moreau defends Matisse against the hostile criticism, but soon becomes estranged from his protégé, who is undeniably (yet cautiously) moving away from the Academy, while sporting an already old hat— Impressionism.

BACKTRACK
THE CAILLEBOTTE BEQUEST

As a member of the Impressionist group, **Gustave Caillebotte** (1848–1894) collected his colleagues' work and, upon his death, gave 65 paintings to the French state. A huge scandal ensued among members of the Salon, who adamantly objected to what they perceived as wild-and-crazy new art becoming French national property. Despite their protests, 40 works were accepted and, in 1897, the Caillebotte Bequest was publicly exhibited for the first time in a newly built annex of the Musée du Luxembourg, Paris.

Searching for Discovery with a Pirate Bride at his Side...

In January 1898, Matisse marries **Amélie Parayre.** He's 29. She's 27, boasts of being the granddaughter of a Spanish pirate, and proudly champions her husband's art. These are hard times for the Matisses. Having jumped the Academy ship under Moreau, Henri is casting about to find his place. He is *still* taking classes until 1900, when his teacher kicks him out of school for being too old to be a student. His income *(still* an allowance from Dad) is meager; he picks up odd jobs, like painting decorations for the 1900 Universal Exposition. And his family is growing. In January 1899, **Jean-Gérard** is born; **Pierre** follows in 1900, and **Marguerite,** Matisse's daughter by Caroline, comes to live with them. Amélie helps support the family by working as a milliner (more hats!) and runs her own shop from 1899 to 1903. She makes herself endlessly available to Henri's work and moods, posing for his paintings, reading to him, and accompanying him on midnight rambles to calm his frequent bouts of stress-induced insomnia. She runs the household so that nothing disturbs her husband. *In short, Amélie is a rock!*

FYI: Posing for Henri—Matisse worked in vying states of anxiety, panic, bliss, and fervor. He was known to weep, talk to himself, sit paralyzed for hours, burst into a frustrated rage, or become so concentrated as to lose all track of time. To be on the posing end was, no doubt, *demanding.*

Cures for Nervous Tension

Besides art, the two things that Matisse devoted himself to were music and exercise. All were attempts to sublimate his oppressive anxiety. He went on long walks and took up horseback riding and rowing as a means of exhausting himself. Even his violin-playing was undertaken with tiring vigor.

Meanwhile, Matisse continues to rehash the history of contemporary art:

Amélie Parayre (Mme Matisse) in Corsica. 1898

- **In pursuit of Impressionism:** On Pissarro's advice, Matisse honeymoons in England to see the English landscape painter **J. M. W. Turner**'s (1775–1851) marine scenes (smoldering with stormy weather). When the Matisses subsequently travel to Corsica (his first taste of the Mediterranean), Henri paints the landscape with a Turneresque glow.

- **On to Pointillism:** In 1899, while reading a treatise by artist Paul Signac (1863–1935), Matisse experiments with Pointillist techniques. His brushwork and color become more systematic, regimented by little dots of unnatural color that twinkle like Christmas lights in the tonal gloom of Matisse's (still dreary) palette.

FYI: It's 1899 and he's showing few signs of the Colorist he will become.

BACKTRACK
POINTILLISM

Formulated by **Georges Seurat** (1859–1891), whose monumental *A Sunday Afternoon on the Island of La Grande Jatte* was first exhibited in 1886, and expounded by **Paul Signac** (1863–1935), Pointillism was a Neo-Impressionist movement named for the little stippled dots of color that cover the canvas. The style attempted to blend optical impressions and memories into a representational afterimage. Also called **Divisionism.**

A Post-Impressionist Breakthrough

Just when you've begun to despair that this story is *going nowhere* (imagine how Mme Matisse must have felt), Matisse has the most important encounter of his career: **He discovers the painter Paul Cézanne.** In 1899, Matisse purchases a small painting of *Three Bathers* (c. 1880), which he keeps as a touchstone, even when the family is desperate for cash. The example of Cézanne pitches Matisse into *a perpetual search for pictorial volume* (Matisse calls Cézanne "a sort of god of painting"). A nude of 1900–01, *Standing Model/Nude Study in Blue* (see opposite page), shows the impact: the figure seems constructed from slabs of pigment; she stands in a space that is solidly composed—no little dots, no fuzziness. **She also marks the beginning of Matisse's preoccupation with the female nude.** And, trivial as it seems, the tone of the painting is blue (yes, brisk blue, no more dreary brown), like a Cézanne, whose work also inspires Matisse to make **his first major sculpture.**

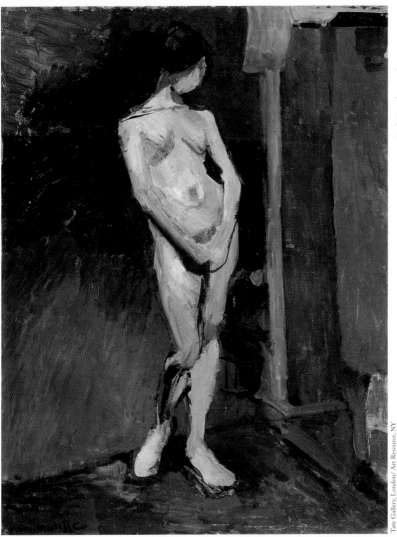

*Standing Model/
Nude Study in Blue*
1900–01
28 ³/₄ x 21 ³/₈"
(73 x 54 cm)

> **FYI: Matisse as collector**—Matisse is a passionate collector of works by other artists, as well as of tribal artifacts, pottery, textiles, and objects in general. His first art acquisition is a pair of drawings by Vincent van Gogh, bought through the Australian artist John Peter Russell (1858–1930) during a holiday in Brittany in 1897. In his later years, he collects plants and *live birds,* which flutter around his studio. To gain familiarity with Matisse's art is to recognize his favorite objects and artworks, which he returns to again and again. More than props, he considers them players, not only in his paintings but in his life.

Financial and Domestic Notes

In 1901, Dad stops the allowance, a decree that it's time for Henri to quit this nonsense and start earning a decent living to support his family. Amélie, the rock, is having health problems and closes her hat shop. Matisse hatches a plan to entice subscribers to pay him a monthly stipend in exchange for art. The plan fails. The Matisses are down on their luck.

The Post-Impressionists attempted to depict subjective reality by transforming the traditional stuff of representational painting—line, color, perspective—into **abstract or symbolic expressions.** Their typical subject matter was nature and *an idealized life within it*; their images are never fleeting. **Not members of a movement per se,** the Post-Impressionists worked separately from one another to formulate, during the 1880s, independent paths out of Impressionism and the Realist/Naturalist tradition. Each of the key figures is associated with a distinct legacy, and Matisse sampled them all.

Paul Cézanne (1839–1906), based in Aix-en-Provence, France. *When you see shattered planes, think Cézanne.* Cézanne envisioned the world in terms of delicately structured planes and surfaces that simultaneously describe volume, perspective, and light. Living like a hermit, he worked in relative obscurity. His impact on the avant-garde was delayed until 1895, when the Paris dealer Ambroise Vollard (1867–1939) showed work that would galvanize generations to follow (most dramatically, the Cubists). What they responded to was Cézanne's attempt to reconcile the imperfect world of perception with the substance underlying those perceptions that he *knew* to exist. The resulting images—clumsy and cerebral at once—give bony structure to something as ephemeral as light.

Paul Gauguin (1848–1903), based in Brittany and then Tahiti. *When you see paradise, think Gauguin.* Gauguin, who advocated drawing from **memory and imagination,** not from life, spent his days searching for a **primitive paradise.** His paintings are characterized by flat, dry surfaces composed of short brushstrokes, in hallucinatory colors.

Vincent van Gogh (1853–1890), based for a while in Arles, France. *When you see expressionism, think Van Gogh.* During his brief life, Van Gogh pushed painting to the limits of observation. His work expresses the emotional intensity with which he observed life through the use of **exaggerated color, forceful design,** and **vividly rendered drawing.** While he was alive, Van Gogh's work received little public recognition, though he worked in close communion with his peers. After his death, he was a celebrated martyr. The first major exhibition was held in Paris in 1901.

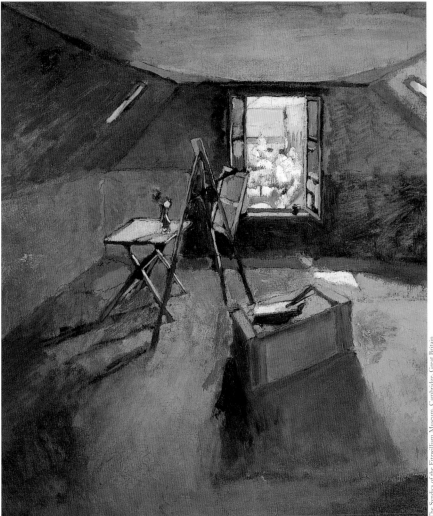

He Goes For It!

Matisse demands to be taken seriously. At school, his seniority and personal intensity make him a leader among students, who also tease him for his tendency to pontificate. (Coworkers once nicknamed him *"jambon,"* or **ham.**) At the same time, they respect his inspiring dedication and the force of his ideas. Out in the real world of professional artists, Matisse moves right into an advanced context:

OPPOSITE
Studio under the Eaves. 1901–02
21 $^1/_2$ x 17 $^1/_2$″
(55 x 44.5 cm)

- He exhibits with the artist-organized Salons that include many future Fauves; in a 1904 exhibition his painting *Studio under the Eaves* receives critical praise. (It also introduces a major theme in his art: the open window.)

- He is included in group shows at Berthe Weill's new gallery, which makes the first gallery sale of his work in 1902.

- He receives his first one-artist exhibition in June 1904 at the gallery of Ambroise Vollard (Cézanne's dealer); the brochure essay praises Matisse for his interesting take on...Cézanne.

But basically, his work remains cautious. Matisse's preoccupations with Rodin (a little behind the times) and Cézanne (a little ahead) are not mainstream avant-garde fare. Then, in 1904, Matisse creates the painting that makes him appear the innovator of the day. (And, in part, it's *because* he has the reputation of being cautious that his next works appear so revolutionary.)

38 ¹/₂ x 46 ¹/₂" (98.5 x 116.5 cm)

Musée d'Orsay, Paris, France. Erich Lessing/Art Resource, NY

The Picture: Matisse painted this paradise— half remembered, half dreamed—after spending the summer in St. Tropez, soaking up Mediterannean sunshine. The shoreline, the boat, and the zeppelinlike clouds come from the paintings he made directly from nature that summer.

The Quotes: The painting is littered with quotes. The title refers to a poem by **Charles Baudelaire** (1821–1867): a lover's plea to journey to a paradise where everything is luxurious, calm, and voluptuous. The theme of a golden age evokes the work (and political metaphors) of Puvis de Chavannes. The bathers are quoted from **Jean-Auguste-Dominique Ingres** (1780–1867), the Neoclassical artist of hot harem girls painted with cool restraint. They also refer to Cézanne's bathers. The presence in their nudie midst of one fashionably dressed dame, perched on the edge of a picnic blanket, is a splash from the cocktail of modern and classic motifs mixed by **Édouard Manet** (1832–1883) in his Impressionist 1868 masterpiece *Le Déjeuner sur l'herbe.* The painting itself, the stippled application of color, is sort of Pointillism. In fact, Matisse spent his holiday hanging out with Neo-Impressionist buddy **Paul Signac** (1863–1935), who proudly purchases this prodigal painting from Matisse.

If it's so smarmy with quotes, why is this painting so important? Even at his most original, Matisse is always in (smart) dialogue with other art. (Remember, one of his essential points of reconciliation is *to maintain continuity* — with his own art, with the past— and *be inventive* at the same time.) What's important is that this dialogue is something he invents. *It's constructed.* So is **the color.** Once he starts laying down those dots, he jetisons the rules of Pointillism and goes for unnatural vibrancy: *the beach is searing hot with red polka-dots!* **The brushwork** is equally irreverent; obeying no representational system, it's part stippled, part drawn, part painted, and (most egregious) *part not even there:* Matisse leaves a lot of space for color to breathe. Altogether, the flagrant anti-naturalism, the inventive arbitrariness of this proto-Fauve picture signals new directions in Matisse's art for his contemporaries to follow.

Bronze. 37 ³/₈ x 13 ⁵/₈ x 13" (92.3 x 34.5 x 33 cm), including base

The Museum of Modern Art, New York. Mr. and Mrs. Sam Salz Fund. Photograph © 1999 The Museum of Modern Art, New York

What: The guy has a downcast expression because, as Matisse scratched right on the base of the sculpture, he's *Le Serf!* Basically a slave, a peasant laborer for a feudal lord.

Why no arms? Good question. Matisse's interest in sculpture stemmed from his discovery of volume in paintings by Cézanne. Note how light settles on faceted planes to make volumes of the serf's body: that's *Cézannesque.* But you couldn't explore sculpture without coming up against **Auguste Rodin,** who had already asserted with his armless *Walking Man* that "you don't need those things to walk." Standing firm, Matisse's double amputee also calls to mind Rodin's *Balzac* commission, which, in one state, presents the famous writer *buck naked,* pot-bellied, and legs astride. But the most explicit reference is plastered all over the surface: Matisse's modeling smacks of Rodin's expressionistic handling of clay.

Personal Proof: Matisse deliberately used this image of a *man* to toughen up his art. He slaved over *Le Serf,* working and reworking it during four important years of transition. When he begins, as a 1900 self-portrait shows, he's feeling pretty sorry for himself toiling away on art that doesn't seem to be going anywhere. But when he finishes, he's on the brink of his Fauvist style. So, check out *The Serf's* knotty physique: Years of labor have made him strong!

Cool thing to know: The man Matisse hired to pose was Bevilaqua, one of Rodin's old models.

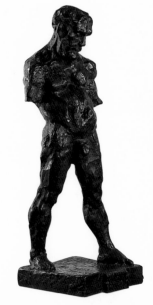

King of the Beasts: Matisse's Fauve Period, 1905–06

The year 1905 is the turning point of Matisse's career. *Luxe, calme et volupté* is exhibited in the Spring Salon, where it confirms Matisse as a leader among contemporary artists. He returns to the Mediterranean for the summer with his family, this time to Collioure, near the Spanish border. His new colleague **André Derain** (1880–1954) joins him. Ideas bounce back and forth between the two painters, who dare each other on. *Matisse's work is decisively experimental.* He explores painting:

- **as Morse code:** *Woman Beside the Water (La Japonaise, Mme Matisse)*, a study of Amélie in a figured kimono, is coded abstraction with dashes of color swished onto bare canvas.

- **as mosaic:** *The Roofs of Collioure* shows tiles of radiant pigment.

- **as sheer hallucination:** *The Open Window* is shown two—count 'em—two ways at once! The view is all bouncy handwriting. The walls and window frames are luscious strokes.

BACKTRACK
AUGUSTE RODIN

Auguste Rodin (1840–1917) is the most famous French sculptor in the Romantic tradition; his involvement with issues of mass in space anticipate Modern trends. He attempts to represent the very act of creation by depicting ecstatically posed figures covered with the evidence of their origins: modeled, pummeled, squeezed, pinched, and caressed clay. The antitheses of his visceral sculpture are Rodin's ethereal drawings. Simple pencil contours and a splash of watercolor are all that render nude female models. Curiously, when Matisse showed his drawings to Rodin in 1900, Rodin advised him to add more detail.

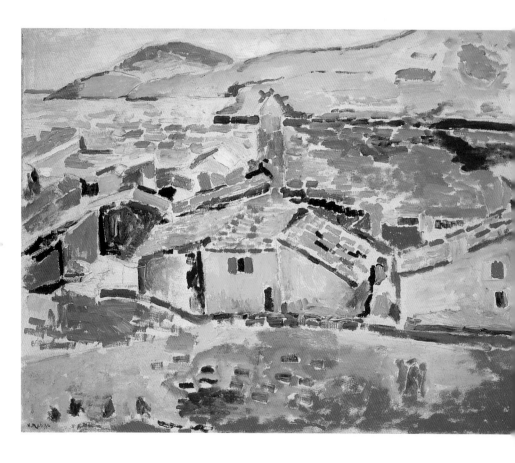

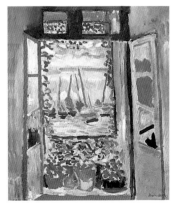

OPPOSITE PAGE
The Roofs of Collioure
1905
23 ³/₈ x 28 ³/₄."
(59.5 x 73 cm)

THIS PAGE

LEFT
Woman Beside the Water (La Japonaise, Mme Matisse)
1905. Oil and pencil on canvas
13 ⁷/₈ x 11 ¹/₈"
(35.2 x 28.2 cm)

The Museum of Modern Art, New York. Purchase and partial anonymous gift. Photograph © 1999 The Museum of Modern Art, New York.

RIGHT
The Open Window
1905
21 ³/₄ x 18 ¹/₈"
(55.2 x 46 cm)

Private Collection.

Back in Paris, Matisse keeps on a roll. Amélie poses for *Woman with the Hat* and is transformed into a monster, her face highlighted with the lilac, forest green, and lemon yellow that is splotched on the background. Her hat is piled sky-high with bizarre decorations. When the collector Leo Stein sees this painting at the infamous Fall Salon of 1905, he declares it **"the nastiest smear of paint"** he's ever seen. Then he buys it with his sister, the writer Gertrude Stein, and their brother Michael, a banker. At the Salon, Matisse's new work, hanging alongside similarly spirited paintings, creates a public furor. The critic Louis Vauxcelles names the new style when he expresses pity for a sculpture (that looks vaguely Italian Renaissance) standing forlornly in their midst, "Ah, Donatello amongst the *Fauves.*"

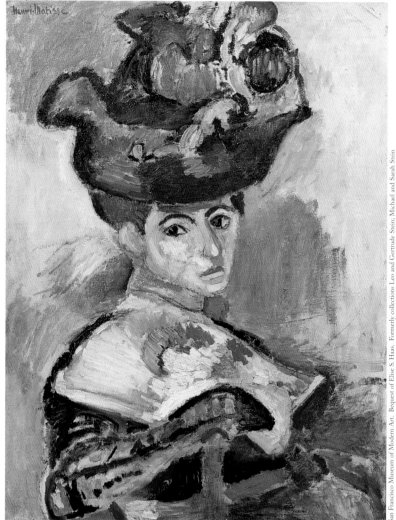

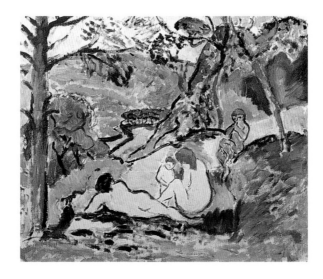

LEFT
Pastoral
1906
18 ¹/₈ x 21 ⁵/₈"
(46 x 55 cm)

Musée d'Art Moderne de la Ville de
Paris, Paris, France. Giraudon/Art
Resource, NY

OPPOSITE
*The Woman
with the Hat*
1905
31 ¹/₄ x 23 ¹/₂"
(80.6 x 59.7 cm)

Time Out: *Is that a Fauve in my Soup?*

Fauve is French for "wild beast." Considered **the first avant-garde art
movement of the 20ᵗʰ century,** Fauvism was short-lived: 1905 to
1908. It lasted just long enough to launch art's liberation from Realism
(and from the duty of describing nature)—a liberation that was already
implicit in the Post-Impressionist work of Cézanne, Van Gogh, and
Gauguin (whose art was so influentially on view during the first years
of the century). **Color for color's sake** was the movement's main line
and was used to describe *emotional, spatial,* and *decorative* effects—in

short, the whole enchilada. **André Derain** (1880–1954) and **Maurice de Vlaminck** (1876–1958) were Fauves too.

Working Rhythms

During his Fauve period, Matisse lets color rip. It's almost as if he lets his palette run wild just to see if he can bring it back under his control. Control underlies his every effort. This is a period of *supreme confidence,* from which a rhythm emerges between pictures that are observed (stylistically inconsistent; excited, often brutal; colorfully effusive) and pictures that are composed (structured by design; analyzed; often elegant; simplified).

Each deliberately reconciles and counteracts the other: The nearly tie-dyed *Woman with the Hat* is juxtaposed to the four-square *Portrait of Mme Matisse/The Green Line,* another image of Amélie, this time with her face turned fully forward, for greater simplification. In lieu of the frivolous *chapeau,* her hair is a knot on her head, a dark stopper clamped atop a masklike face, which has been bisected from top to bottom by a wide green line into two different expressions. *And this tug of war never stops.* As you will see, Matisse spends his entire career compulsively working (observing) and reworking (composing) the same basic images—women reading or otherwise absorbed, windows, nudes—over and over and over again....

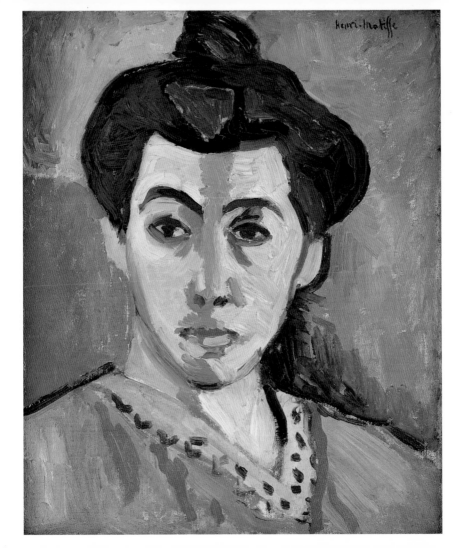

Abdication

Having just been hailed King of the Fauves, Most Colorful Guy of 1905, Matisse writes anxiously to Signac that he needs to find more structure in his art. In *Le Bonheur de vivre,* he readdresses *Luxe, calme et volupté* (with many of the same quotes—the Ingres-like figures, for example). But this time there are no allusions to modern life, no picnic irony, no Pointillism. It's an image of sheer pastoral joy; *bonheur* is, after all, French for "a good time." Men and women loll erotically in the foreground of a forest glade while others dance in a circle in the meadow beyond. (**Cool thing to know:** Picasso's Modernist shocker, *Les Demoiselles d'Avignon,* began as a response to this composition.) *BUT*, the major dissent is color: No one was laying down areas of unmodulated color like this. Plus, **it's Matisse's biggest picture yet,** at nearly 6 x 8 feet. It requires that a special studio be rented. As his sole entry in the 1906 Salon, it creates an even **bigger stir.** Even his

Le Bonheur de vivre
1905–06
68 ½" x 7′ 9 ¾"
(174 x 238.1 cm)

NEAR RIGHT
André Derain
1905
15 ¹/₂ x 11 ³/₈"
(39.4 x 28.9 cm)

Tate Gallery, London/
Art Resource, NY

FAR RIGHT
André Derain
*Portrait of Henri
Matisse.* 1905
18 ¹/₈ x 13 ³/₄"
(46 x 34.9 cm)

Tate Gallery, London/
Art Resource, NY

OPPOSITE TOP
*Blue Nude:
Memory of
Biskra.* 1907
36 ¹/₄ x 55 ¹/₄"
(92.1 x 140.4 cm)

OPPOSITE BOTTOM
*Reclining Nude
(I)/ Aurora*
Bronze. 1906–07
13 ¹/₂ x 19 ³/₄ x
11 ¹/₄"
(34.3 x 50.2 x
28.6 cm)
Musée National d'Art Moderne,
Centre Georges Pompidou,
Paris, France. Erich Lessing/
Art Resource, NY

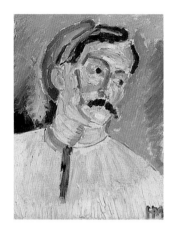 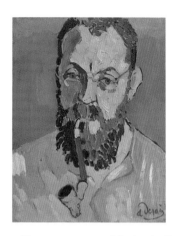

supporters hate it. Like Moreau, Signac tears up Matisse's Rolodex card. The structure and synthesis are not crude—*not Fauve*—enough. Nor is Matisse, as revealed in two telling anecdotes:

- Derain says he took Matisse home to impress his family with his friend's bourgeois rectitude. (Family members worried that all artists were absinthe-doped bohemians.)

- Vlaminck, who prided himself on being the wildest Fauve, could never play violin with Matisse, because Vlaminck always wanted to play *fortissimo* to The King's careful renditions.

Not satisfied to sling colors, the King of the Beasts was apparently about to abdicate.

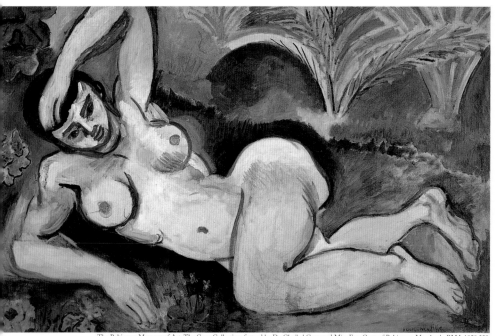

The Baltimore Museum of Art: The Cone Collection, formed by Dr. Claribel Cone and Miss Etta Cone of Baltimore, Maryland. BMA 1950.228

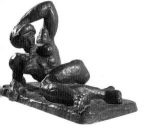

From Beast to Primitive

Following his initial revulsion, Leo Stein declares *Le Bonheur de vivre* "the most important painting done in our time," then buys it. And Matisse takes Amélie on a holiday to North Africa. In 1907, back in Collioure, France, he paints *Blue Nude: Memory of Biskra* (see previous page). Like *Le Serf,* this is a toughening-up image. The figure pushes against the frame, she's bigger than the bed, and (don't be shy) **her thigh and hip look like a penis!** This aggressive odalisque (i.e., concubine in a harem) embodies savage sexuality: She is the antithesis of the lithe classical figures in *Le Bonheur de vivre.* (Some have seen this painting as a tribute to Cézanne, who had just died, and to the power of his legacy.) The odalisque evokes Matisse's interest in Primitive art, which leads him to look at and learn from:

- **His children's art,** as exemplified by the 1906–07 portrait of his daughter, marked by heavy outlines and her name scrawled across it. (The black ribbon around Marguerite's neck hides a tracheotomy scar left from an emergency childhood operation.) *When Picasso and Matisse traded paintings in 1907, this is the one Picasso (another aficionado of things Primitive) selected.*

- **Tribal art** (all of the Fauves were buying it), as exemplified by Matisse's 1906 purchase of an African carved-wood head, which he shows to Picasso one night at Gertrude Stein's place—which in

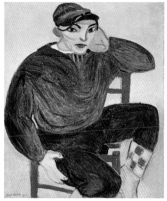

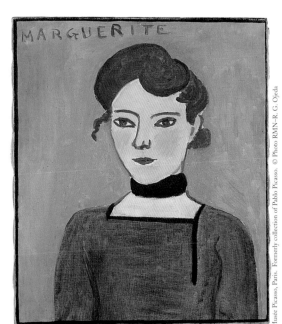

turn sparks a radical and immediate impact on Picasso's art. For Matisse, the influence is more subtle and long-lasting. African art suggests the kinds of expressive distortions he creates in the *Blue Nude* and offers a way of exploring issues of Cubism without entering fully into the movement. Even for his cutouts of the 1940s, Matisse cites African art as an inspiration.

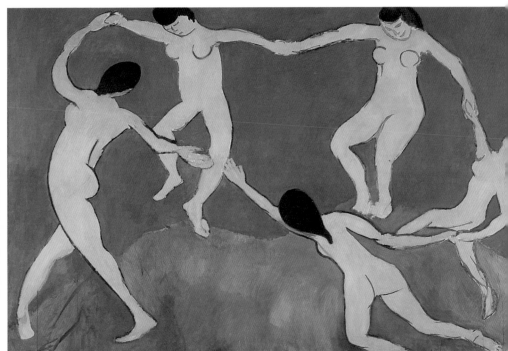

- **Giotto** (1267–1337), as exemplified by Matisse's *Dance I*, which owes its expressive and friezelike composition to his enormous interest in Giotto. This Proto-Renaissance painter is considered a Primitive in that his style is, on the surface, only approximately classical.

Art and Decoration (1908–13)

Primitivism plays an important role in Matisse's work, providing him with models for achieving *the essential simplification* that he and all Moderns quested after. (You cannot begin to understand Fauvism and Cubism without some knowledge of this phenomenon.) But even *more essential* to Matisse is **decoration.** Around the turn of the century, the decorative arts were the subject of major cultural re-evaluation, especially in France, where good taste is practically a national treasure. One account might be that Industrial Design was putting a new (manly) face on the traditionally decorative (feminine) arts. In any case, some essential points to recall, when considering Matisse's art in light of the decorative, would include his:

- **Modern sensibility:** In 1906, the French government

BACKTRACK

PRIMITIVISM

A major phenomenon of Modernism. Europeans and Americans regarded cultures outside of the direct impact of Western society and technology (what we like to think of as civilization) to be in their *childhoods* and, thus, appropriate subjects for dominance. Deemed incapable of anything philosophically complex, Asians, Africans, all indigenous peoples, peasants, and other "primitives" were thought simple, superstitious, and naïve. As such, their cultures were readily exploited by avant-garde artists seeking alternatives to traditional representational values. (Of course, the fallacy of Primitivism is that its subjects are not in formative or degenerative stages of our culture; they *are* their own cultures.) Despite its original air of chic, today Primitivism reflects the naïveté of its beholders.

started purchasing decorative as well as fine arts from the Salons. In turn, artists were encouraged to be well-rounded in their production. Matisse's work of the teens is marked by his experiments in sculpture and ceramics, as well as in painting.

- **Decorative principles:** Matisse had an eye for overall design. Critics compared the way he *deformed* his figures to the way artists of the Romanesque period—as well as Flemish and Chinese artists (all so-called Primitives)—*misinterpreted* and *exaggerated* their subjects in order to make them conform to an overall pleasing composition or architectural situation.

- **Decorative patterns:** Matisse used designs that he found in wallpaper and textiles (you'll notice favorite pieces of fabrics being used repeatedly) to bring structure and pattern into his paintings. He cites as an important model Persian miniature paintings, in direct response to which his 1911 work *The Painter's Family* is a meticulously complex organization of patterns and perspectives. The checks on the checkerboard, for example, represent two different points of view. (Later, we'll see how the decorative impulse explicitly intersects with **Orientalism.**)

- **Decorative potential:** Throughout his career, Matisse realizes his art's decorative potential in projects that include sets and costumes for the Ballets Russes 1920 production of Stravinsky's *Le Chant du rossignol,* for mural decorations, illustrated books, designs for wall

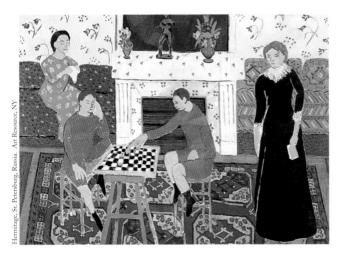

The Painter's Family. 1911
56 ¹/₄" x 6' 4 ³/₈"
(143 x 194 cm)

hangings and textiles, and, in the late 1940s, for an entire chapel, from its stained-glass windows to the priestly garbs.

- **Decorative slurs:** Nonetheless, Modernism's relationship to the decorative has always been iffy, at best. To call an artist's work "decorative" was as scorching then as it is today. When contemporary critics likened Matisse's paintings to **wallpaper,** *they weren't celebrating.*

Manifestos

In 1908, Matisse turns his recent manifestos on painting into an influential essay and he founds a school. In January, the **Académie**

Matisse opens with an enrollment of 10 and will balloon to 120 during its three years of operation. His own involvement is minimal, giving just two crits a week; but his course is demanding. He encourages students to use their imaginations, but makes them draw from plaster casts and perform other academic exercises. *(He tears up any Fauvist-style work they produce.)* Students must start at the beginning and originate their own approaches. The school closes when Matisse realizes that he's fed up with trying to motivate everyone.

In December, his "Notes d'un peintre" ("Notes of a Painter") is published in *La Grande Revue*. It is a treatise—part defense, part explanation—of his own art and is deemed to be among **the most important statements by an artist in history.** Instantly translated into Russian and German, it spoke internationally to artists of the day. The gist is that Matisse says he wants to:

- create an art in which **ideas** are not separate from means (line, color, shape)

- condense **sensations** from nature into enduring images

- use **color** (in amounts and tones) that intuitively reflects its essential character in nature, without imitating it

- make art that conveys its significance through the **order and clarity** of its composition, even before the viewer recognizes what's illustrated

- create paintings that will **soothe and calm** the mind (see the armchair quote on page 11)

- make art that is **based on nature** —and thus avoids any pictorial preconceptions—while remaining **true to the expression of his time.**

Sound Byte:
"What I am after, above all, is expression. But the thought of a painter must not be considered as separate from his pictorial means. I am unable to distinguish between the feeling I have about life and my way of translating it."
—MATISSE, "Notes of a Painter," 1909

Financial and domestic notes

In 1909, Matisse joins the Bernheim-Jeune Gallery, which guarantees to sell every easel-scaled canvas he paints. His financial security assured, the Matisses move to an elegant home with green shutters in a Paris suburb, Issy-les-Moulineaux: It boasts a big garden, a pond, and space for a huge new studio to be constructed. Matisse and the kids take up horseback riding. His means have, at last, caught up with his temperament—and the whole family enjoys *haut bourgeois* livin'.

Bring on the Dance

OPPOSITE
*Harmony in
Red/La Desserte*
1908
70 $^7/_8$″ x 7′ 2 $^5/_8$″
(180 x 220 cm)

Harmony in Red was purchased by the Russian collector **Sergei Shchukin,** who in 1909 commissions Matisse to create a set of murals for the stairwell of his Moscow home. He is inspired by seeing *Dance I,* a huge canvas that Matisse painted (in two days!) of the same circle that figured in *Le Bonheur de vivre,* now made monumental. In *Dance II,* Matisse's second version for Shchukin, things have really heated up: The dancers' bodies have turned from pink to fiery red; the background has also intensified to deeper shades of blue and green. Here are some further cues for considering the two works:

- **Reconciling peasant dances and "disco":** Matisse says he was inspired by memories of folk celebrations which he saw echoed in such popular routines as the lively Provençal dance, the farandole: "Dancers hold each other by the hand, they run across the room, and they wind around the people who are standing around." (He says he whistled the dancehall tune while he painted.) In citing these sources, Matisse deliberately infuses his painting with jolts of "primitive" and popular culture.

- **From fun to frenzied:** In *Dance I,* the drawing and physical expression of the dancers are lyrically light and loose; in *Dance II,* they're raw and urgent, an instinctual dance of life or death.

- **From Golden Age to *élan vital*:** From I to II, one can also detect

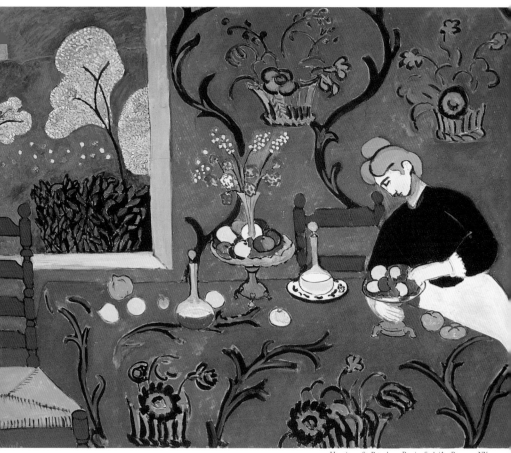

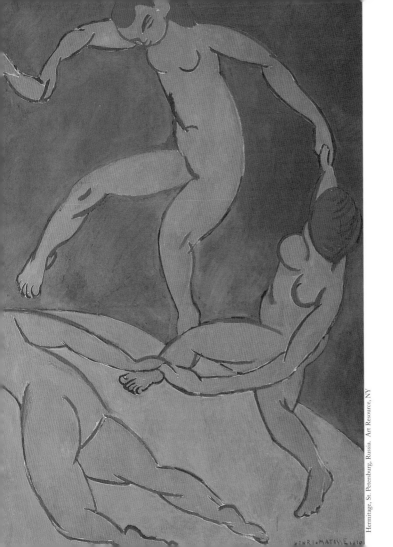

Dance II
1909–10
8' 5 ⅝" x 12' 9 ½"
(260 x 391 cm)

Hermitage, St. Petersburg, Russia. Art Resource, NY

in labor strikes and increasingly fractious relations between Allied France, Germany, and Russia a rising loss of faith in utopian politics. There's a feeling of impending war, and with it, the promise of a new era. A popular philosophy, as expressed by the French philosopher Henri Bergson (1859–1941), is based on the notion of *a universal life force*. The antithesis of Darwinian evolution, it's an **incitement to action** to shake off any last vestiges of the over-cozy 19th century and embrace a radically pared-down future.

- **Shall we dance?** Note that the hands of one of the pairs (in both circles) of dancers are pulled apart by centrifugal force, a pictorial energy that jumps the gap like electricity to complete the circle's *eternal unity*, but also leaves room for the viewer to plug into.

Sound Byte:
> *"This dance was* in *me."*

—MATISSE

In contrast to the dancers' tense, torquing bodies, one sees sedate figures in *Music*, Matisse's second mural for Shchukin. Same colors, but a completely different energy. The standing violinist (Matisse played the violin) leads the line of seated figures in this work that reconciles creative energies: Only after physically knocking yourself out in **extreme dynamism** can you attain a **calm, composed expression.** Distressed by the outrage these works elicited in the 1910 Fall Salon—

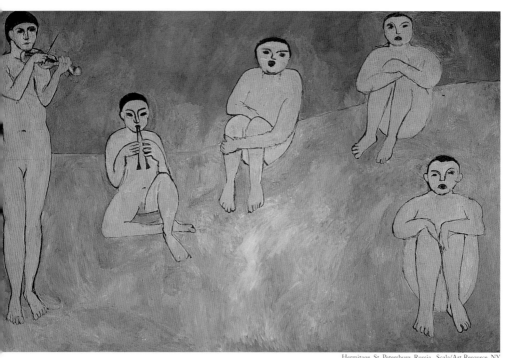

Music
1910
8' 5 ⁵/₈" x 12' 9 ¹/₄"
(260 x 389 cm)

critics found them an incoherent mess of archaic images and expressionist handling—Shchukin temporarily chickens out. In October, Matisse's father dies and he travels alone to Spain, where he basks in anxiety, disgust, and mourning (Dad was, after all, his most inspiring goad to success). Shchukin capitulates and sends for the murals, which are installed as planned, except that the collector then has the genitals of the flute player painted over so as not to shock his little nieces.

OPPOSITE
The Pink Studio
1911
70 $^5/_8$" x 7' 3"
(179.5 x 221 cm)

Art animates Life

Music and *Dance* are part of a period of works in which Matisse makes art a presence in contemporary life:

- His touch grows **lighter, looser.**

- **The narrative vanishes** in images animated exclusively by art.

- He paints **still lifes** that assert the role of the decorative by mixing his own art right in with the flowers, furniture, and other **decorations.** (It's almost a game to pick out the art.) They radically synthesize high and low, representation and reality, into one harmonious image.

- He paints **studio interiors,** as in *The Pink Studio,* in which paintings shine like windows onto their own spaces—other realities. They declare **the growing importance of studios** as cultural sites,

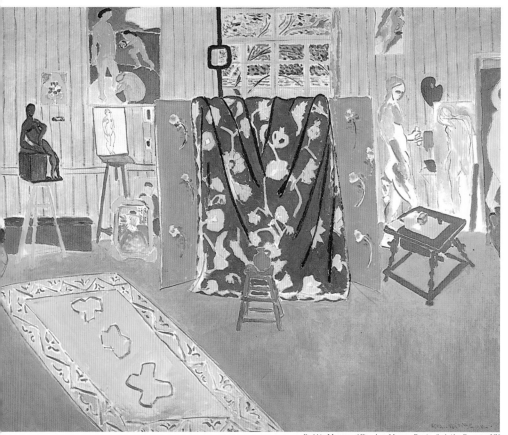

OPPOSITE

LEFT
Back I
1908–09. Bronze
6' 2 ³/₈" x 44 ¹/₂" x
6 ¹/₂"
(188.9 x 113 x
16.5 cm)

Tate Gallery, London/Art
Resource, NY

RIGHT
Back IV
1931. Bronze
6' 2" x 44 ¹/₄" x 6"
(188 x 112.4 x
15.2 cm)

The Museum of Modern Art,
New York. Mrs. Simon
Guggenheim Fund.
Photograph © 1999
The Museum of Modern Art,
New York

private worlds where families of related forms come into being. (Artists begin inviting photographers and the press to represent them in their studios.) In *The Red Studio*, Matisse uses red—his color of interiority—to unite the objects of his imagination.

Matisse's Sculpture

Until 1950, Matisse periodically turned to sculpture, consistently with the same basic purpose: to experience his images as volumes. A very Cézannesque thing to do. Indeed, perhaps Matisse's most important (and sustained) foray into three dimensions comes from the figures in the *Three Bathers* painting by Cézanne that Matisse owned. *The Backs* is a series of four monumental bronze relief sculptures made over a period of 23 years. (They are now located in the courtyard of The Museum of Modern Art in New York.) Each shows a female figure viewed from behind with one arm raised. To see all four together is to see a representation that begins as an abstraction and turns into an even stronger image of itself. *The Back I* (1908– 09) is complexly

Matisse was patronized by a series of private collectors (none of them French) who shared a taste for advanced art of the day.

The Steins: Americans in Paris. Leo (a painter) and his wife, Sarah, along with his sister, the writer Gertrude Stein. They collected Matisse intensely from 1905–08. During this period, Matisse frequented Gertrude's apartment, a salon of avant-garde artists, writers, and musicans. Chunks of the Steins' collections were bequeathed to the San Francisco Museum of Modern Art.

Sergei Shchukin: Moscow textile dealer. Stops collecting in 1914, when World War I cuts him off from Paris. His collection becomes property of the State during the Russian Revolution and ends up in the Hermitage Museum in Saint Petersburg.

Albert Barnes: American patent medicine millionaire. Starts collecting in 1914. Commissions murals for his foundation (and home) outside Philadelphia, where his collection remains on public view, idiosyncratically displayed as Barnes installed it.

Dr. Claribel and Etta Cone. Sisters with family money living in Baltimore. Become proud owners of *Blue Nude: Memory of Biskra* in 1926, followed by many other significant works, which now form the Cone Collection at the Baltimore Museum of Art.

faceted with lots of knobby planes that become progressively flatter and more simplified, so that by the time you get to *The Back IV* (c. 1931), the body is just two slabs bifurcated by a coil of hair. What's amazing is that they never lose their sensual mass, even at their most severe. *The Back IV* is almost more powerfully physical than *The Back I* for being the most suppressed; it clearly involves the greatest force of abstraction, the force of shoving a giant into a bronze envelope. And talk about surfaces: If you ever get a chance to see *The Backs* lined up with natural light playing over their surfaces, you're in for a *consummate art thrill.*

OPPOSITE
*Portrait of
Sarah Stein*
1916
28 $\frac{1}{2}$ x 22 $\frac{1}{4}$"
(72.39 x 56.52 cm)

San Francisco Museum of
Modern Art. Sarah and Michael
Stein Memorial Collection.
Gift of Elise S. Haas

Art-historical bait-and-switch

Matisse treated other images—such as the portrait heads of *Jeanette*—to similar sculptural progressions, from abstract to abstracter to abstractest. These works have been seen as demonstrations of his interest not only in Cézanne but also in African tribal art and Cubism. In a famous series of Cubist sculptures, Picasso reduced his girlfriend Fernande's head from a Gorgon tangle to an animated pile of potato chips. But Matisse never went that far—his images never so fully dissolve into abstraction. Thus, what his sculptures are thought to show is how he dealt indirectly with issues of Cubism *through* Cézanne and African tribal art. Matisse turns to sculpture in his search to substantiate his perceptions. He frequently makes sculptures of figures he also painted, as if creating his own models or building on his own

The 19th-century Romantic
phenomenon of Orientalism is
based, like Primitivism, on Western
misconceptions of non-European
culture. Accordingly, Primitives
are *children* and the Orient is the
world of the *feminine,* both to
be dominated by the *masculine*
West. As a geography, the Orient
extended from North Africa to
India, representing all things
decorative, sensual, and per-
fumed. Embodying all this is the
great icon of Orientalism, the
odalisque. As she appears in
paintings from Ingres to Renoir,
she is a harem girl, usually recum-
bent, always a sex object. Despite
Orientalist fantasies, harem chicks
were not available on every
Casbah corner. An essential artist
in the Orientalist camp is
Eugène Delacroix (1798–1863).
His influential theories—the first
to promote color as a structuring
device in painting—inspired
others, including Matisse, on
colorful quests for the exotic.

plans. *Blue Nude: Memory of Biskra* was preceded by a bronze nude in the same pose.

Matisse the Tourist

Tourism is a truly modern phenomenon. Brought on by railroads, steamships, and other *industrially revolution-ized* forms of transportation, travel became not only an increasingly popular pursuit, but an industry in itself. As a cultured tourist, Matisse develops his art with reg-ular doses of travel to see exhibitions (Munich, 1910: an important show of Islamic art), collections (Moscow, 1911: his patron Shchukin's collection), and architecture (Spain, 1910: Moorish monuments) and to taste the exotic (Morocco, 1912–13). These are just a few items from *one period* of constant travel, throughout which Matisse, the paradise pleasure seeker, follows the sun all over the coasts of France and Spain, even to Polynesia.

Matisse at the Casbah

Henri and Amélie Matisse spend the winters of 1912 and 1913 in Morocco. (The Casbah, or Kasbah, is the citadel, or old fortified part, of the city of Tangiers.) Whereas other artists inspired by Orientalism may have

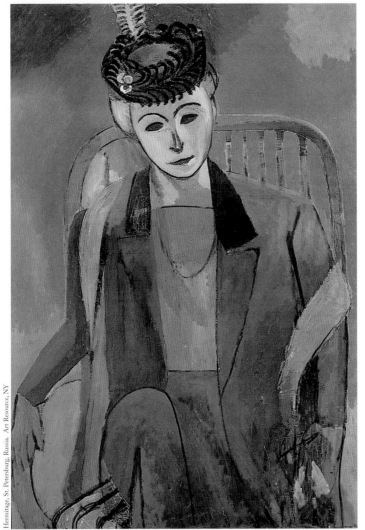

*Portrait of
Mme Matisse*
1913
57 x 38 ⅛"
(145 x 97 cm)

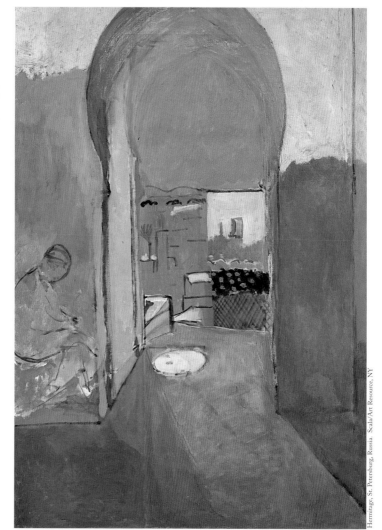

The Casbah Gate
1912–13
45 ⁵/₈ x 31 ¹/₂"
(116 x 80 cm)

traveled with only vaguely conceived expectations of the exotic, Matisse sets out to find affirmation of his already highly sophisticated sense of the decorative. He knows what he is looking for: glowing light, bold patterns, flowing garments, cool shadows, ripe fruit. And judging from the paintings he makes in North Africa, he is not disappointed. *Well, not after he settles in.* When he first gets there, it rains for two weeks. On his second trip, Matisse arrives before the winter rains have transformed the parched landscape into the verdant one he remembers. After things begin to bloom, Matisse responds fully.

What's to know about Matisse's Moroccan paintings?

- **Liberating effect of nature:** The surrounding landscape, architecture, and people of Morocco actually allow Matisse to paint more naturalistically than inside his Paris studio, where he imagined or staged his decorative tableaux. For Matisse in Morocco, environment supersedes style, affording him *the quality of relaxation.*

- **Color is newly complex:** In *The Casbah Gate,* for example, notice all the gradations of shadow in the many shades of blues (from cobalt to turquoise), which Matisse observes in late afternoon when pink, pearly light pours through the city.

- **Space, too, is newly complex:** Matisse has an ingenious way of making things seem near and far at once, and *Landscape Viewed from a Window* is an example. Vases on the window sill, figures in

the street, and buildings in the distance establish three levels of pictorial depth. At the same time, everything seems to hang in a void of blue shadows and sky that dissolve any real sense of depth.

- **Goldfish arrive:** Matisse picks up this motif (which we will see a lot of) in Morocco, where they are common objects of contemplation: Men in cafés stare into the depths of goldfish bowls. One appears in *On the Terrace* in front of a seated girl named Zorah, whom Matisse met on his first trip to Morocco.

In Tangiers, Muslim women lived sequestered indoors or behind veils. (The street urchin Zorah was one of the few females Matisse found who would pose in full-facial nudity; by his second trip she had become a prostitute.) Seated demurely between a pair of slippers and the fish in a bowl, Zorah appears caught within the limits of her world, between pictorial attributes of escape and entrapment.

> **FYI:** When Matisse returned from his second trip, he composed the *Moroccan Triptych*, which consists of the three paintings described above (*Landscape Viewed from a Window, On the Terrace,* and *The Casbah Gate*). Several years later, he painted *The Moroccans*, a three-part montage (of the Casbah, Muslims, and melons) based on vivid memories from these influential trips.

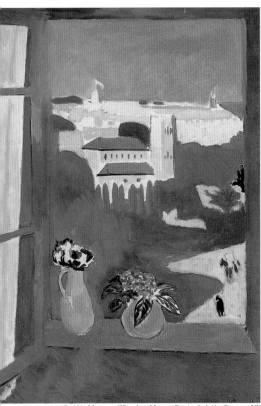

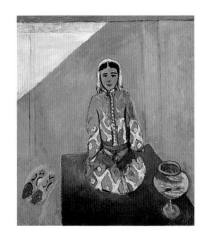

ABOVE
*On The Terrace
(Zorah).* 1912–13
45 $\frac{1}{4}$ x 39 $\frac{3}{8}$"
(115 x 100 cm)

LEFT
*Landscape Viewed
from a Window*
1912–13
45 $\frac{1}{4}$ x 31 $\frac{1}{2}$"
(115 x 80 cm)

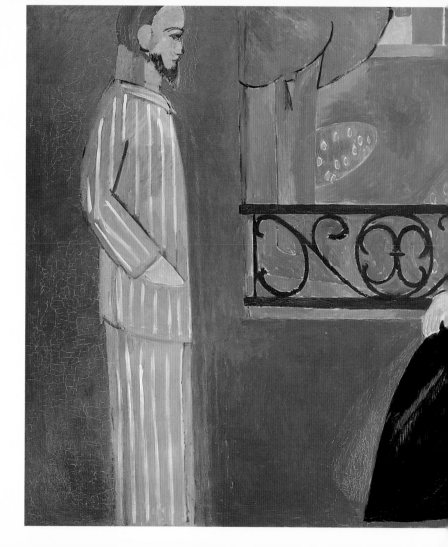

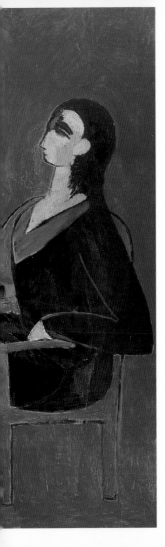

THE CONVERSATION, 1908–12
69 5/8" x 7' 1 3/8" (177 x 217 cm)
Hermitage, St. Petersburg, Russia. Art Resource, NY

What: A morning face-off between M. and Mme Matisse. He's completely inflexible. Wirelike stripes on his pajamas hold him taut. His mask of a face makes their conversation into **a primitive battle of the sexes.** She, in her bathrobe, seems unable to tear herself from that imprisoning chair, while her body strains up toward him. Her forehead is clouded with a stain (her brooding thoughts?). The window only widens the gulf between them.

Most severe: For Matisse, this painting has unusually personal repercussions. He started it as a counterpart to *Harmony in Red,* a picture energized with vibrant color and patterns of arabesques. In contrast, *The Conversation* is cool and brittle to the point of arctic freeze. (Did he set it aside because he couldn't face its intensity when he was, in fact, having *an affair with one of his students?*) It initiates the period of severe abstraction that characterizes Matisse's ensuing experiments with Cubism.

Mais Non! In this icy portrait of a marriage, the conversation boils down to one word of denial, keeping the woman at bay. Encrypted into the balcony grillwork is the word *"Non!"*

"Non" what? The man, *literally created by art,* is wholly determined in his position, unwilling and unable to admit *the compelling life force* of the woman in the chair.

BACKTRACK

CUBISM

Comes historically just after Fauvism and is the next major innovation in modern art. It, too, was named by the critic Louis Vauxcelles, who described what he saw in a 1908 exhibition of paintings by **Georges Braque** (1882–1963) as "little cubes." Originated by Picasso and Braque, Cubism sought a completely conceptual interpretation of reality. It *assassinated* naturalist tradition, as represented by Impressionism. In the Cubist world (modeled with devotion to Cézanne's), color is almost nil; still life is preferred over real-life subjects; and space is a wreck of simultaneous points of view. The agitated surfaces of Cubist pictures emerge on impact between **angular linear shards** and **massive volumes**.

Matisse in America

In 1910, an article featuring Matisse on Fauvism, entitled "The Wild Men of Paris," appears in *The Architectural Record*. It hails the modern movement as "the birth of the ugly." When the International Exhibition of Modern Art—the famous Armory Show that was held in New York in 1913—traveled to Boston and Chicago, works by Matisse and Modernist sculptor **Constantin Brancusi** (1876–1957) were burned in effigy by art students. A sign of how behind times Americans were: It was Matisse's now stylistically dated Fauvist works, especially *Blue Nude: Memory of Biskra*, that provoked the reaction. Now this seems all the more misdirected when you consider that **Marcel Duchamp** (1887–1968) showed a urinal as a sculpture, entitled *Fountain*. A far more outrageous gesture!

The Experimental Years: 1913–16

Having broken with Fauvism to spend 1909–12 ensconced in his studio, Matisse tunes back into the mainstream avant-garde. In 1913, that means Cubism, which he takes up, but without actually embracing it. (Picasso is already its leader and Matisse is no follower.)

He comes to the movement at a very particular moment. Picasso has just finished painting *Ma Jolie,* a Cubist portrait of a pretty girl, like one might meet in a bar, singing the popular tune for which the painting is named. It represents a major shift from the analytical style that Picasso and Braque had developed almost hermetically inside their studios and turns that style onto the streets. Cubism is now a social phenomenon, full of puns and references to pop culture. (It also carries a latent sense of war: snippets from the newspapers found in Cubist collages reveal the political strife.) So, by the time Matisse takes up Cubism, you might say it was practically the view outside his studio window.

Sound Byte:
"I knew we were painting strange things, but the world seemed a strange place to us."

—PICASSO, on the Cubist alien nation

Art Heavyweights: Picasso vs. Matisse

Considered the masters of Modern art, Pablo Picasso and Matisse developed separate, yet parallel, courses to one another. Both were:

- given to radical flip-flops in style

- enormously appreciative of the classical past, of traditional art of the past, of Cézanne, and of the tribal and the exotic

- significantly involved in other mediums besides painting, and notably in the decorative arts

- neighbors when they "retired" to fabulous villas in Southern France

The two were fiercely competitive with each other (Picasso referred to himself and Matisse as the North and South Poles). On the one hand, Picasso was a bohemian with a sensational life story to prove it, a visionary imagist who led Cubism and who was revved with enthusiasm for the revelatory *magic* of African tribal art. Picasso superstitiously attempted to exorcise his fear of women through art. On the other hand, Matisse was a bourgeois with the refined lifestyle that proved it. A visionary colorist, he led Fauvism and was intrigued by African art, while insisting on its historic relation to Egyptian art. Matisse anxiously attempted to transpose his nervous tension into art.

Given that Cubism was antiharmony and anticolor, it would seem also to be anti-Matisse. And yet, this period is a fascinating one precisely because it shows Matisse pushing himself toward unprecedented experimentation:

- He reduces his palette and (most conspicuously) starts swabbing on the **black.**

- Arabesques give way to **sharp angles** (if French curves had been the rule, now the straight edge governs).

- There are **signs of violence:** surfaces are actually scratched off; images are *sheared* into fragments; familiar subjects appear strange.

- A pink-and-white Cubist portrait of his daughter is recognizable only by Marguerite's ubiquitous black ribbon choker.

- A Cubist Mme Matisse as a gently smiling wraith (this is Matisse's last portrait of his wife).

- Another version of de Heem's *La Desserte* is a wild ride through a haunted still life, complete with trapdoors, precarious objects, and mysterious passages.

- In *Goldfish and Palette,* Matisse cuts his own body out, showing just his finger poking crudely through the grayish palette.

Sound Byte:
> *"All things considered, there's only Matisse."*
> —PICASSO

Some have seen the disorienting creativity of Matisse's Cubist period as a reflection of his inherent anxiety aggravated by World War I,

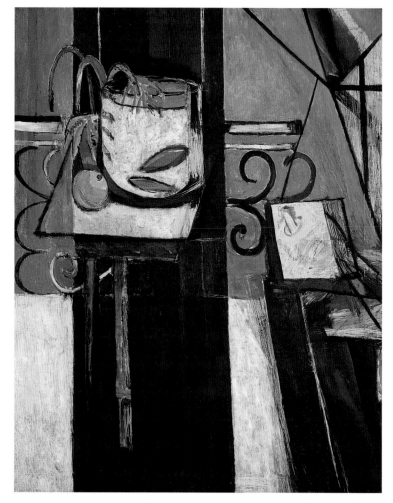

which was declared on August 3, 1914. Just prior to this, he takes a studio in his old building at 19, Quai St. Michel with a view of Notre-Dame Cathedral. German troops advance; Matisse enlists, but is too old to be inducted. The family flees, first to Toulouse, then to the coast, where in the autumn of 1914, he paints possibly the most minimal painting of his career: *French Window at Collioure.* Here, shades of blue pigment frame a central blank of unmodulated black paint. And that's all. He returns to Issy-les-Moulineaux. Throughout the war, Matisse's work is exhibited to an increasingly international audience, with his first comprehensive American exhibition held in January 1915 at the Montross Gallery, New York.

Sound Byte:
"A difficult watershed for me was the period of Cubism's triumph. I was virtually alone in not participating in the others' experiments. Of course, Cubism interested me, but it did not speak to my deeply sensory nature."
—MATISSE

Enter Lorette

In the autumn of 1916, Matisse hires Lorette, a beautiful Italian model, to pose for him. In 1916–17, he makes over 50 paintings of her, initiating the kind of intense involvement he will have with a series of

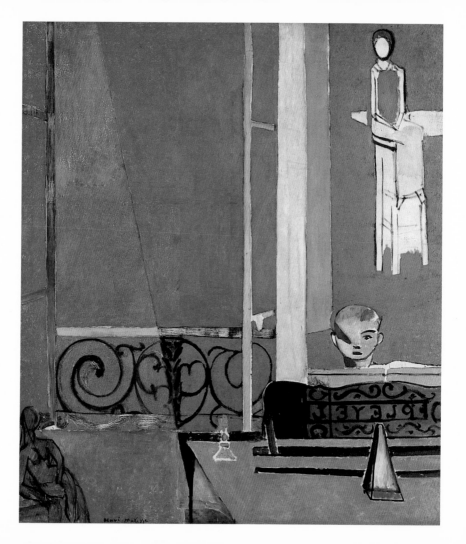

What: A wistful memory. Even though in real life he was practically old enough to run off to war, Matisse's son Pierre appears here as a little boy safely practicing his piano in the house at Issy-les-Moulineaux.

Cubism transformed: The forced abstraction of Matisse's experiments with Cubism have relaxed and grown naturalized—more *Matissean*. What remains is a strongly formal, almost architectonic composition, now evolved into an image of extreme simplicity and harmony. The unifying gray sets off the picture's bare essentials with a subdued sense of minimalism.

Caught for time: Matisse wanted Pierre to grow up to be a concert pianist, and made him practice for hours daily. The metronome on the piano holds the boy so transfixed that it seems to have wiped a measure right off the left side of his face. In contrast to its eternal mechanized beat sits a candle, about to burn out. (That's *vanitas* for you!)

Duty or pleasure: Matisse painted two stylized versions of his own works into the picture: a bronze sculpture of a nude and a painting, *Woman on a High Stool*. They occupy opposite corners of the canvas: One is an image of voluptuous lassitude, the other a prim, upstanding citizen. Pierre is positioned between them. But what dominates the canvas is the window, framed as a void, *a great unknown*.

Cool thing to know: Pierre eluded his father's plans by growing up to be one of the first dealers of blue chip Modern art, with his own gallery in New York.

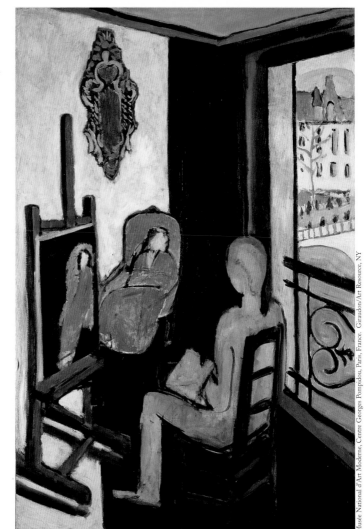

The Painter in His Studio. 1916
57 ⅝ x 38 ¼"
(146.5 x 97 cm)

models throughout the rest of his career. She helps him get over his Cubism. He paints her in a series of pictures that bounce back and forth between sensual indulgence and severe (relatively puritanical) abstraction. He also paints *Bathers by a River,* in which faceless figures stand as colossal columns, emanating a sense of grandeur and classical order. As a wartime *call to order,* it is an image that Matisse himself seems unable to live up to. The more he paints Lorette, the more he relaxes into his own mood. She appears nestled in an armchair, swaddled in a robe (echoes of Mme Matisse in *The Conversation*), caught up in her own daydreams (not glaring enraged at her husband).

87

When Matisse enters the same picture, he depicts himself as attentive, seated, and…nude! Let's face it, this is not a good sign for the home life: Husband spends days working his mojo by dressing up, posing, and painting compliant babe; wife is at home increasingly chairbound by her rheumatism.

Simply Lovely: The Early Period in Nice (1917–30)

In late 1917, Matisse travels alone to Nice, where he will spend part of every year for the rest of his life. Some scholars overlook Matisse's early Nice period as an almost embarrassing betrayal of the abstract rigors of his previous works. Just pretty girls in pretty rooms, prettily painted. But it's in these works that Matisse gives fullest expression to *his sensual reaction to life.* **These are paintings to savor,** just like the forms of relaxation they represent in an imagery of Gramophones, quiet reading, letter writing, reclining on chaises longues. They avoid overt Modernist references and reflect the artist's ideals of eternal human values (like room service). Yet, they are built on organizing principles of light and color that are completely advanced. Take away the trimming and you have boxes full of light. It's the kind of light that is:

- **palpable** (*feel the light* pouring in through windows and shutters)

- **sheer, warm,** southern (no Paris grays here: light billows through blouses, tablecloths, curtains, making them *translucent*)

- **pulsing** in harmony or in syncopation with decorative color and pattern (these rhythms are *as complex as jazz*).

It's really a marvel how much Matisse makes happen in these compact compositions, balancing bold (often strangely off-key) colors with the strong light and juxtaposing aggressive patterns: stripes, florals, paisleys. But they never appear overpoweringly designed. The spaces themselves are seamlessly manipulated so that you often get impossible double perspective, looking down on the floor and up into a model's face at once. Technically, they embody a variety of approaches, from loose to intimate brushwork, always thinly applied. But the most impressive thing about the Nice paintings is *their charm.* Here's Matisse exerting the full force of his control on paintings that are **meant to look almost naïve,** to be naturally appealing. Things in life are *simply lovely,* these paintings seem to say.

Mirrors, Windows...and a Crabby Painter

He spends his first season at Nice getting in tune with his new surroundings. He paints what is by now a familiar motif: his hotel room with a view out the window. In one work, his suitcase sits unopened on the bed; in another, his violin case is opened on a chair. He gets up very early each morning to practice playing and to beat the heat, as he spends afternoons driving the coast and painting landscapes. His style is sketchy, mapping the new colors and terrain. He

visits Renoir, who is old, crippled, and still churning out impressions of ripe nude girls. Matisse is filled with awe for the man's touching vitality. Renoir crabs back, "In all truthfulness, I don't like what you do," but concedes that his use of color proves that Matisse is "most surely a painter."

It's during his second trip that Matisse really begins to get into his Nice groove. On November 11, 1918, the war ends and he spends Armistice Day with fellow colorist **Pierre Bonnard** (1867–1947), who resides in nearby Antibes. Matisse has settled into the first of the four rooms he will take at the Hôtel de la Méditerranée, where he continues to paint views out the window and an amazing series of studies of a mirror set in velvety blackness. Traditionally, paintings are the mirrors that artists hold up to nature. What's interesting is to see *these* paintings of windows and mirrors—*the* great metaphors of art and nature—as preludes to the completely artificial reality Matisse will create in Nice. Enter **Antoinette Arnoux,** whom Matisse hires to pose in 1918. He costumes her in a dramatic (you guessed it!) hat that he himself fashions from ribbons and plumes. The stunning works that ensue include one of Matisse's most famous series of drawings, rendered in a full range of modes of elaboration and simplicity. They show perhaps more succinctly than any other works the virtuosity of Matisse's expression.

OPPOSITE

The White Plumes
1919
28 ³/₄ x 23 ³/₄″
(73 x 60.3 cm)
The Minneapolis Institute of Arts

Sound Byte:
"A colorist makes his presence known even in a single charcoal drawing."
—MATISSE

OPPOSITE
Matisse at age 50

Matisse's Drawings

A hangover of Matisse's academic training was his conviction that drawing was the foundation of all visual art. *If you can't swim, you can't surf; if you can't draw, you can't paint.* There are corollaries in drawing for every major and minor movement of his career, from Fauvism to (at the very end) a series of bold black-ink drawings. He considered them equal to his paintings and called his famously economical line, "the purest and most direct translation of my emotion." Another essential thing to know about Matisse's drawings is that they are as much about color as are his paintings: *Matisse used values of black to bring out shades of white.*

More Financial Notes

The public loved Matisse's Nice paintings so much that he could renegotiate his gallery contract at even higher premiums. His 1924 exhibition practically sold out before the opening. This was also a time of

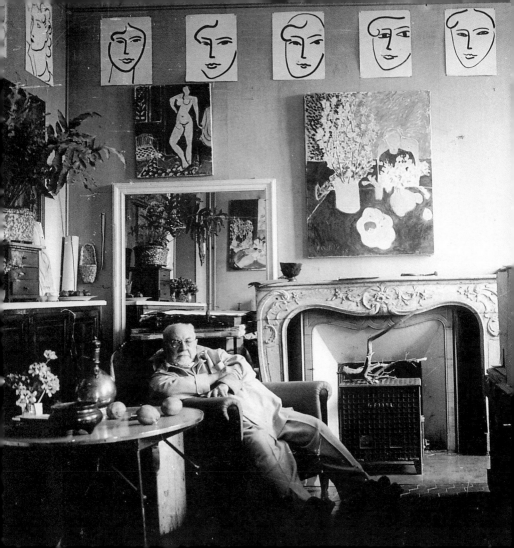

major retrospectives, held in Copenhagen (1924); in Berlin (1930); and, in 1931, in Paris, Basel, and New York (at the newly opened Museum of Modern Art).

Memories of Morocco Regained

During his 1921–22 season in Nice, he takes the apartment that he will live in until 1928 and transforms it into **a theater of Oriental delights.** To set the stage, he has movable frames built, upon which he can hang different fabric backdrops, arrange into sets, then add props with still-life objects and girls. He starts hiring extras from a nearby movie studio to pose for him. Some, like Henriette Darricarrère, acted their part so well that they helped Matisse shape the fantasies they inhabit. And they are very much inhabitants, members of a Modernist harem. Some are so extremely objectified, *they appear indiscernible from sculpture.* These are unabashedly sensual paintings. There's no yearning, no irony, no abstraction. As realized by Matisse, paradise is now a pictorial reality.

Things Domestic

Matisse's wife and children visit him from time to time in Nice. He spends summers in Paris or at Issy-les-Moulineaux, where he brings Antoinette to visit in 1919. He paints a wonderful snapshot-style picture of her and family members in the garden, with the dog in mid-scratch.

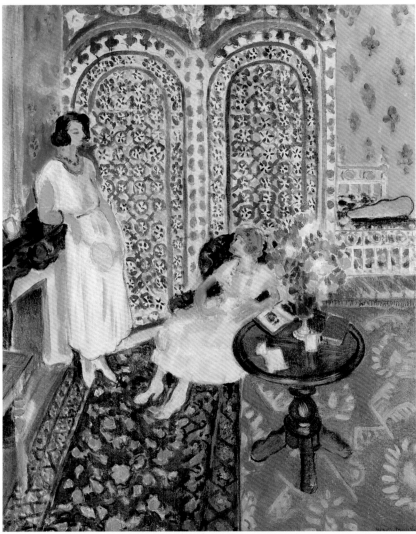

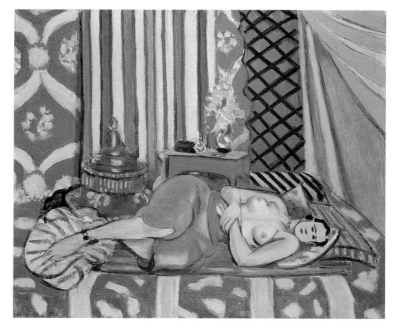

But basically, he's on his own. In December 1926, Mme Matisse takes an apartment in Paris, where Matisse stays when he's in town.

Hanky Panky?

Who knows what went on between Matisse and his models. He had discrete affairs all his life and ended up living with one of the models.

Given how passionate Matisse was about his art, one wonders if anything could really have surmounted the pleasures he had in composing and creating these paintings—so sensual in themselves—including sitting so close to nude girls and women that he could touch them? In one photo, he shows himself working with his hand on his model's knee!

Themes and Variations (1930–43)

From Paradise to Polynesia to Pennsylvania: In 1929, Matisse announces that his Nice days, as we know them, are over. He goes on a five-year hiatus from easel painting. "Nowadays, I want a certain perfection," he tells an interviewer. He sails to Tahiti, taking a train across America, to arrive in the city of Papeete on March 29, 1930. Like Gauguin, who journeyed there in 1891, Matisse is disappointed with what he finds. (Paradise is rarely what one *imagines*.) The trees, for example, he finds to be too small, and the weather, always so beautiful, is boring. It's only some 20 years later, when he returns to his impressions *as memories*, that he translates his Tahitian experience into art.

Sound Byte:
"The first time I saw America, I mean New York, at seven o'clock in the evening, this gold and black block in the night, reflected in the water, I was in complete ecstasy. It seemed to me like a gold nugget."
—MATISSE, on arriving in New York harbor in 1930

In the autumn of 1930, Matisse travels again to America, this time as a juror (he was last year's big prize winner) for the international exhibition held annually by the Carnegie Institute in Pittsburgh. The jury grants the award to...Picasso! Matisse travels to Merion, Pennsylvania, to see Picasso's work installed for the Barnes Foundation. Barnes proposes a mural commission, which Matisse accepts. He sees a baseball game, then goes home to Paris to start work.

Dance, Redoux

One of the highlights of the Barnes Foundation collection is *Le Bonheur de vivre*. This work had already provided the imagery for his first mural commission (for Shchukin), and Matisse returns once more to that circle of dancers. This time the specifications involve a sequence of three lunettes, situated above tall windows. Matisse rents an abandoned warehouse in Paris, where he initiates the **two new techniques** that will come to predominate his late work. Both are answers to problems.

- **How to compose color and design on such a large scale and maintain a balance between masses?** Solution: Use **cutouts** as patterns. An early composition shows how compulsively Matisse moved the patterns around, pinning and repinning them to the canvas, adding bits, until he finally felt ready to move on *to the next problem.*

- **How to enlarge images to architectural scale without losing the**

sense of intimacy and spontaneity that come directly from touch? The solution: Make a longer pencil! For the final versions, Matisse used a piece of charcoal attached to the end of a long stick that allowed him to draw enormous figures directly on the canvas, using sweeping gestures. Of course, it was a daunting physical feat, but Matisse says that once he got over his initial *paralysis,* he sketched the whole thing in one fast move.

The mural is sent off and is returned: *It's too small.* Matisse had received the wrong dimensions. The *second* final version is installed in Spring 1933. Compared to the throbbing expressionism of Shchukin's mural, the colors and movements of the Barnes commission are light and limpid. Painted pale fresco shades (Puvis, can you hear me?), they float above eye level, without appearing to compete with the other art or garden views below. This is exactly what Matisse desired.

Sound Byte:
"One will feel my picture rather than see it."
—MATISSE, on his murals for the Barnes Foundation

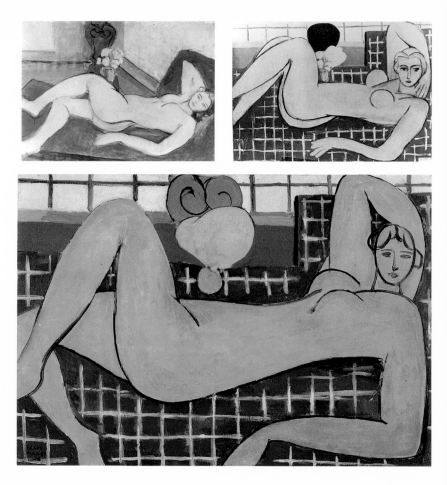

LARGE RECLINING NUDE, 1935
(formerly known as THE PINK NUDE)

What a history! It comes after the break from easel painting that began in 1929. Matisse worked on this painting continuously from April to October 1935.

And there's evidence to prove it: The elaborate process behind this painting is documented in an amazing series of 22 photographs, which he sent one by one to the Cone sisters in Baltimore. They show how the image evolved through states of relaxed naturalism and Cubist abstraction with the figure growing larger and larger (sometimes through the use of "pasties": cutouts of paper attached to the canvas) until the reclining nude becomes what she is: a **streamlined advertisement of abundant sensuality.** The photos also reveal that the blobs in the background clearly began as a spiraled chair-back and a tiny vase full of yellow blooms.

Prefigures "Themes and Variations": At every stage, however, Matisse was working with supreme confidence, seeing just how far he could go toward reaching his conclusion. And he continued to paint with assurance. This period culminates in 1941 with a book of line drawings entitled *Themes and Variations.*

What Matisse said of these works also perfectly describes the successive states of *The Pink Nude.* He called them "the cinema of my sensibility."

Cool Thing to Note: The model is Lydia Delectorskaya, a young Russian who assisted Matisse on the Barnes commission. Now acting as model too, she would jump up at the end of the day's posing and (after a photograph was taken) carefully wipe off the parts of the painting that Matisse wanted to rework during the next session.

OPPOSITE TOP LEFT: *Large Reclining Nude, State I.* TOP RIGHT: *Large Reclining Nude, State XIII.* BOTTOM: *Large Reclining Nude* (formerly, *The Pink Nude*). 1935. 26 x 36" (66 x 92.7 cm). All three images from The Baltimore Museum of Art: The Cone Collection, formed by Dr. Claribel Cone and Miss Etta Cone of Baltimore, Maryland.

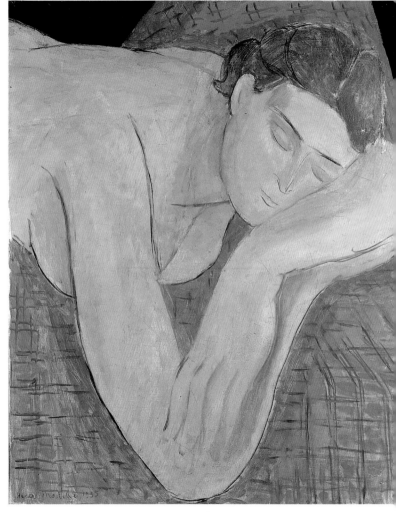

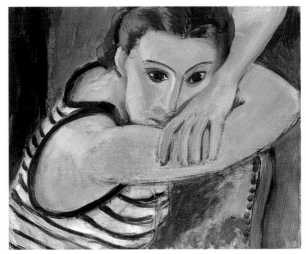

War & Cancer

Matisse spends the war years (1939–45) in Nice, part of unoccupied
Vichy France, in a villa called Le Rêve. A less dreamy time is had by
Amélie and Marguerite, who join the Resistance, are captured by the
Gestapo, and are imprisoned. Marguerite is tortured, but escapes from
a train en route to a concentration camp and lives in hiding until the
liberation. Matisse, who has no news of the women throughout the
war, undergoes an operation for cancer in 1941, which leaves him an
invalid. Remember, Matisse came to art through convalescence. Now,
in his seventies, recuperation again catalyzes reinvention.

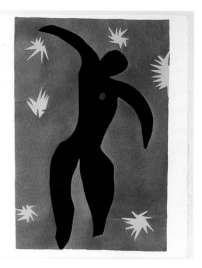

Icarus, Plate VIII from *Jazz* 1947. Pochoir, printed in color, each double page 16 ⁵/₈ x 25 ⁵/₈" (42.2 x 65.1 cm)

OPPOSITE
Matisse at his villa in Vence, 1948

Jazz

Restricted to wheelchair and bed, Matisse turns to drawing. In 1942, a friend, publisher Emmanuel Tériade, proposes a book project that inspires in Matisse a radically new form of decorative art. Working directly in paper, **Matisse creates 20 cutouts.** The technique he explored while composing the Barnes murals now becomes *an end in itself.* One of the most beloved artists' books of this century, *Jazz*— for which Matisse also wrote the text —is a modern scrapbook of impressions, memories of past works, thematic concerns, myths, and

dreams. Perhaps its most iconic image is of the boy *Icarus,* who was punished by the gods for daring to fly. Matisse shows him falling back to earth, a black silhouette against a starlit sky, his proud heart a red beat of passion. When it was published in a magazine in 1945, *Icarus* was seen as emblematic of an indomitable French spirit. And in fact after the liberation, Matisse and Picasso were honored in Paris as national heroes for staying (when they could have easily fled) and upholding cultural standards that defied Nazi dominion for all the world to see.

Last Works (1948–54)

Conceived as a "thank you" to the Dominican nuns who nursed him after his operation, the Chapel of the Rosary at Vence (1948–51) is the consummate expression of Matisse's art. It is a total environment in which the artist designs everything from the building to the windows to the altar to chasuble robes for the priests. And while one might expect it to be overtly decorative — given Matisse's penchant for ornament—the place is pristinely minimal: all white, save the stained-glass windows, which bathe the interior in a blue and yellow glow, and color the black-line wall drawings on white ceramic tile.

Archive Photos

After the architectural scale of Vence, Matisse never goes back to easel painting. He devotes his last years to creating cutouts—the fresh closure to his artistic legacy. Working right up to the end, Matisse dies

Maquette for red chasuble (back) designed for the Chapel of the Rosary of the Dominican Nuns of Vence 1950–51 Gouache on paper, cut and pasted 50 ½" x 6'6 ½" (128.2 x 199.4 cm)

Coll. D'Arte Religiosa Moderna, Vatican Museums, Vatican State. Scala/Art Resource, NY

on November 3, 1954, in Nice. He is buried in Cimiez, near the Musée Matisse.

Memories of Oceania and Beyond

The imagery of the cutouts is largely of paradise, much of it watery. There are lagoons, swimming pools, fish, waves, seaweed, and swimmers. Matisse says he's thinking about Tahiti, where he experienced **a sense of the cosmos** swimming in the ocean, absorbed in the cool

Interior with an Egyptian Curtain. 1948
45 ³/₄ x 35 ¹/₈"
(116.2 x 89.2 cm)

INTERIOR WITH AN EGYPTIAN CURTAIN, 1948

What: A still life on a table in front of window, which is draped with an exotic textile.

When: This painting is among the last Matisse made. He stopped painting in 1951 to devote his final years to decorative projects and cutouts. The impact of the cutout technique is easy to see in the clipped flat shapes that compose this painting.

Raw power: Red, yellow, and black dominate the palette of these last paintings, giving them an incendiary brilliance, made bold by the crudeness of their compositions. In these very last paintings, Matisse compensates for his physical infirmity with sheer pictorial aggressiveness. Maybe he isn't as dextrous in his control of the brush, but his decorative vision is *more dominant than ever.*

Nude with Oranges
1952–53
Gouache on paper, cut and pasted, and brush and ink on white paper
60 3/4 x 42 1/4"
(154.2 x 107.1 cm)

Musée National d'Art Moderne, Centre Georges Pompidou, Paris, France. Erich Lessing/Art Resource, NY

underwater world and the jewel-colored reefs, then popping his head out of the water, and entering a whole other cosmos of brilliant sky and blinding sunlight. *If this isn't a glorious picture of the hereafter,* coming from someone at the end of a full and satisfying life!

Sound Byte:
"The essential thing is to spring forth, to express the bolt of lightning one senses upon contact with a thing. The function of the artist is not to translate an observation but to express the shock of the object on his nature; the shock, with the original reaction.

—MATISSE

Grande Finale

Why is Matisse's art so beautiful? Henri Matisse envisioned his art as a paradise of repose. His pictures aim to transport us outside of our everyday concerns, away from the stresses of modern-day life and into a world of color, harmony, beauty, and light. In terms of his own life, this is exactly what art did: It rescued Matisse from the routines and pragmatic concerns of his original career in law, a profession that he successfully pursued until illness left him temporarily bedridden. In contrast to the boredom of law-clerking in an office, Matisse found in painting a glimmer of paradise.

Rock my world: After the first book confirming his achievements was published in the 1920s, Matisse worked for decades as a historic has-been—a living Old Master. Then suddenly, in his 80s, he starts making art that rocks with contemporaneity.

Cubist holdout: Cut directly out of colored paper then pasted into place, Matisse's cutouts are a form of collage. As a 20th-century technique, collage is a Cubist invention—their way of inserting elements of the real world into a constructed one. Having avoided it all these years, Matisse now takes up collage without fear of impunity: no chopping up of old newspapers for him. These collages are completely of his own making, as are its paper elements, drawn with scissors.

The ultimate reconciliation: For Matisse, these patently decorative cutouts encompass painting, drawing, and sculpting at once:

- The silhouette form allows him to synthesize the color of painting with the line of drawing.

- He compares the act of **carving directly into color** with that of cutting into stone (the lyrically simple forms are reminiscent of the sculptor Rodin's late contour drawings).

- The cutouts are **composed spatially** by pinning elements directly to the walls (Matisse uses his palatial apartment at the Hôtel Régina as an architectonic canvas).

- They are conceived as frieze **decorations,** wall hangings, models for prints, and tapestries.

Corbis-Bettmann

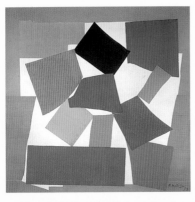

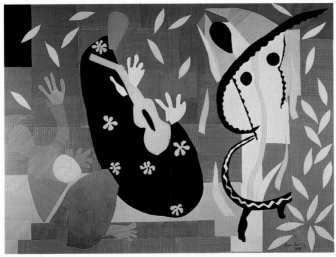

LEFT
The Snail
1953. Gouache
on paper, cut
and pasted, on
white paper.
9' 4 ³/₄" x 9'5"
(287 x 288 cm)

Tate Gallery, London/
Art Resource, NY

BELOW
*The Sorrows of
the King.* 1952
Gouache cutout
pasted on canvas
9'7" x 12'8"
(292 x 386 xm)

Musée National d'Art Moderne,
Centre Georges Pompidou, Paris,
France. Giraudon/ Art Resource,
NY

OPPOSITE
*Matisse making
cutouts*

Despite his father's protests, Matisse attended art school and embarked on a painting career. The fact that he was a generation older than his creative peers, that he had a family to support and was determined to be taken seriously in his chosen field gave him a certain authoritative edge. Matisse emerged as a leader of the Fauves. Considered the first Modern art movement, Fauvism made a definitive break with the 19th-century Realist representation by using color as a *total means of expression.* As a visionary colorist, Matisse's legacy lies in the assertion that he looks with his mind as well as with his eyes: Nature informs, but does not dictate, his perceptions. He left the mainstream avant-garde to independently explore issues of Cubism and to champion the *decorative* (and pure beauty) as a respectable goal for fine artists. He traveled to Morocco, then settled in Nice, where he conjured images of exotic, stunningly refined beauty in charming depictions of a hotel harem world.

In his late years, Matisse moved away from easel painting and devoted his energy to decorative commissions, illustrating books, making murals, and designing tapestries. Just as history was about to close the book on him, he invented a breathtaking new body of work: the cutouts, a combination of painting, drawing, and sculpture that consummated a lifetime devoted to reconciling an anxious temperament and highly intellectual talent in an art that apparently denies its own complexity. But to get the essence of his achievement, just think of music: A stellar performance is one that *seems* effortless. Matisse practiced hard-to-compose images that radiate, simply, an ambience of beauty and joy.